A–Z

OF

KINGSTON UPON THAMES

PLACES - PEOPLE - HISTORY

Julian McCarthy

AMBERLEY

For Dylan

First published 2019

Amberley Publishing
The Hill, Stroud, Gloucestershire, GL5 4EP
www.amberley-books.com

Copyright © Julian McCarthy, 2019

The right of Julian McCarthy to be identified
as the Author of this work has been asserted in
accordance with the Copyrights, Designs and
Patents Act 1988.

ISBN 978 1 4456 8537 3 (print)
ISBN 978 1 4456 8538 0 (ebook)

British Library Cataloguing in Publication Data.
A catalogue record for this book is available
from the British Library.

Typesetting by Aura Technology and Software
Services, India. Printed in Great Britain.

Contents

Church memorial carved at a time when these was no 'J' or 'U' in the alphabet.

Introduction

It appears a natural trait that we take things for granted, seldom questioning their existence, until they are drawn to our attention – an index at the rear of a book, for example. We assume it will be there and are somewhat surprised and even disappointed when we find that there isn't one. (Spoiler alert – there isn't one!)

Pursuing this thought further, we take for granted that any index will be arranged alphabetically. Why? We seldom, if ever, give thought to the alphabet and why c follows b or s precedes t; it just does. It is the reason this book is called the *A– Z of Kingston upon Thames* and not 'the H to R...' etc.

We give little thought to the invention that is 'the alphabet' and how it is used both to communicate vocal sounds, different languages and enable remote parties to 'talk' to each other over distance and, indeed, over time. Reading histories of Kingston is only possible because historians set down their thoughts, images and knowledge in arrangements of twenty-six simple characters. Reading these arrangements we 'hear' the historians 'talking' to us from the past.

A book can therefore be seen as a long-distance telephone call, where someone wishes to tell you something and you 'listen' to what they have to say. They may have called you previously and so try not to repeat themselves, but equally, they may again touch on things you've heard before to remind you or in case you didn't hear (read) their earlier call. They impart what they find interesting, hoping that you do too.

This A–Z is a collection of people, places and incidents that, hopefully, will make you think about the town, who or what has gone before and, perhaps, what is happening now that will be written about to speak to the future.

Thomas Abbott

What would you have done in Victorian times if you had broken a treasured piece of china? Hopefully you would have visited Mr Thomas Abbott, an internationally famous repairer of broken china, at No. 35 High Street.

In 1889, to demonstrate his expertise, he broke a jug into 289 pieces and, using hand drills, files, pliers, 615 rivets, solder, plaster and cement, he restored it such that it could hold water again. In celebration of Queen Victoria's Diamond Jubilee, he made a patchwork vase out of 1,540 separate pieces of pottery.

Below left: Abbott's repaired jug. (Photo courtesy of Kingston Museum)

Below right: Abbott's patchwork vase. (Photo courtesy of Kingston Museum)

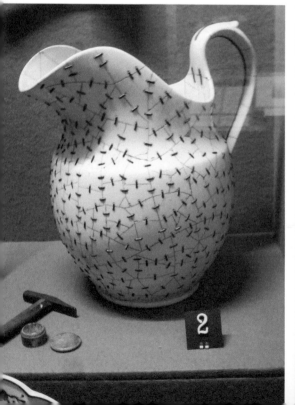

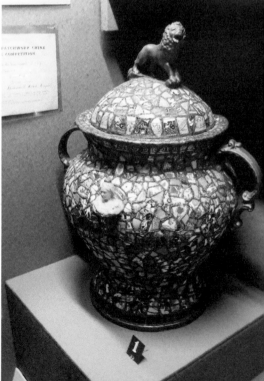

Abbott's reputation extended far beyond Kingston and in 1909, when Wedgewood's 1774 'Frog Service', made for Catherine the Great, was exhibited in England, Abbott was commissioned to repair some damaged pieces and his repaired pieces are today on display in the Hermitage, St Petersburg. However, you only need to visit our museum to see the ewer and vase, my two favourite exhibits and unique to Kingston.

All Saints' Church

All Saints' Church, the nave and tower of which were initially built around 1130, is considered a building of 'exceptional interest'. It is mainly of thirteenth/fourteenth-century construction and has a nave and tower out of alignment, indicating rebuilding of the nave after the twelfth-century tower, which remains hidden, but is accessible to the bell ringers, behind a small door. The south columns of the nave are larger than on the north side, suggesting the mason may have had to compensate for roof loading.

In 838, at a Great Council, convened by King Egbert of Wessex (King Alfred's grandfather) and attended by bishops and nobles, oaths were pledged before an altar. This suggests that the site was a known place of worship and, as the consecrations of at least two accessions have taken place here, the site is considered 'Royal'.

Hand-crafted, medieval floor tiles which reveal the original depth of the floor; the fourteenth-century painting of St Blaise (patron saint of woollen drapers and sufferers of a sore throat); the Skerne brasses depicting fifteenth-century lawyer Robert Skerne

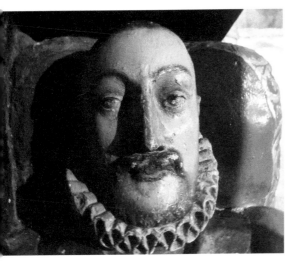

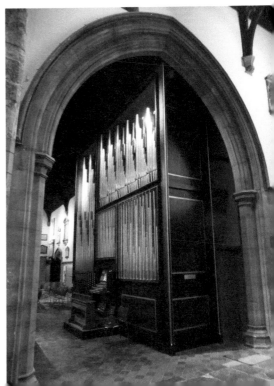

Above: Sir Anthony Benn, attributed to Janssen.

Right: The Frobenius '3 manual, 39 speaking stop' organ, built in 1988.

and his wife that were saved from the church ravages and stripping during the civil war are all worthy of note, as is the grand Frobenius organ, installed in 1988.

The 1618 plaster effigy of seventeenth-century Recorder of London, Sir Anthony Benn, in his lawyer's clothes, attributed to Geerhart Janssen, closely resembles that of Shakespeare's friend John Coombe, sculpted by Janssen at Stratford-upon-Avon. Janssen is attributed to having sculpted the bust of Shakespeare also on display at Stratford.

Assizes

Kingston was an 'Assize' town where the circuit court convened each March for the Lent Assizes.

The arrival of the judges in town resulted in two distinct processions: one a grand affair, with the mayor and corporation leading the judges in a coach guarded by liveried javelin men, to the church and back to the Griffin; and the other a far less grand but more frequent event. Shackled prisoners marched to and from the courts carrying the weight of apprehension in the morning and the burden of sentence in the evening.

Assize judges heard serious cases but, occasionally, judgement was required on what could be considered a triviality. At the 1767 Lent Assizes, such concerned a wager of 100 guineas (£11,000 – i.e. figures in brackets update costs to 2018). William Courtney was sued for the sum wagered by the gentleman who had set the bet. The wager was that the gentleman could procure three horses that should go 90 miles in three hours. The gentleman had furnished three horses which had set off simultaneously. Running together, each covered 30 miles well within three hours. The plaintiff argued that his horses had covered 90 miles in the time and he had won the bet. The Court found for the defendant as it considered that the bet was unfair.

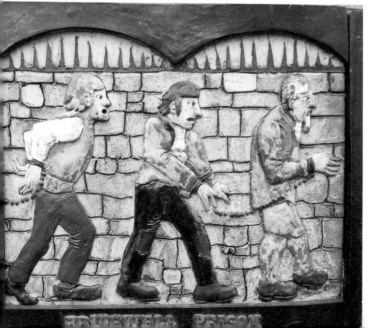

Eden Street mural depiction of the daily procession.

Athelstan

In 925, reputedly on 4 September, in 'Cyinges tun' (King's estate) there took place, for the first time on this island, a 'coronation', the placing of a crown on the head of a king. Before Athelstan, investiture comprised lowering of a war helmet, but Athelstan had seen wreaths on Roman coins and the gold crown of Charlemagne and opted for a circlet of gold with spikes.

Athelstan was elected king of two realms: Mercia and Wessex. His father, Edward, had ruled over both Angles and Saxons but he had not been crowned King. As a joint King of the Mercian Angles and the Saxons of Wessex, Athlestan became the first King of the Anglo-Saxons.

We can see an image of Athelstan's crown on an illustration depicting him presenting a book to St Cuthbert. This image is the earliest contemporaneous portrait of an 'English' king and though attributed as having long flaxen hair, he is shown, somewhat surprisingly, as having ginger hair despite yellow pigment for flaxen colouration being available in the image.

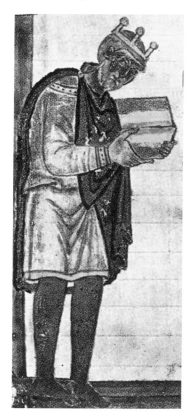 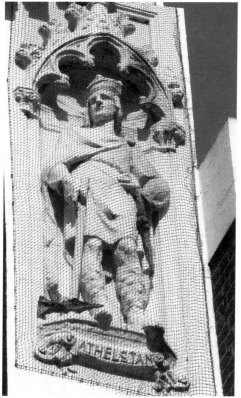

Above left: King Athelstan. The earliest contemporary portrait of an English monarch.

Above right: King Athelstan looking over the Market Place.

Why was the ceremony held at Kingston? Athelstan was raised in Mercia by his aunt, Aethelflaed, and was not immediately accepted as his father, Edward's, successor in Winchester where his brother became King but then died suddenly, only two weeks after accession. Athelstan's younger brothers then plotted against him in Winchester, so that was an unlikely venue. Perhaps it was simply because this King's estate had a fordable crossing between Mercia and Wessex and was a convenient location for nobles from both kingdoms to meet to recognise his accession.

On capturing York in 927, and adding Northumbria to his realm, Athelstan united Angles throughout the country. For the remaining twelve years of his life he was known here and abroad as 'rex Anglorum' (King of Anglia) and is today accepted as the first King of the 'English'.

Lesser known is that foundations of the United Kingdom were set out during Athelstan's reign. Holland writes, 'Athelstan's conquest of York ... can be seen as the decisive event in the making of Scotland, as well as of England.'

Christopher Atkinson

Until recently, all I knew about Atkinson was that he was a master builder who, in 1597, was found drowned in the well of The Chequers pub, later the Old Crown and currently home to Whistles.

However, on viewing parish registers at the Kingston History Centre, I found reference to his marriage to Joan Fox in 1569. They had three children – Elizabeth, Mabel and Thomas – and, in 1581, he was paid 3s and 6d for three and a half days' work around the church. Such extant records bring the history of the town alive. The Kingston History Centre is at the back of the Guildhall and is well worth visiting when you have a moment.

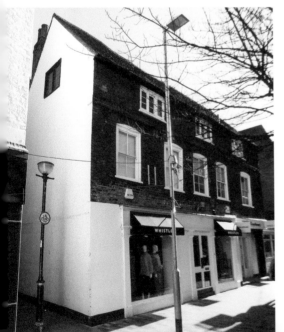

Above: Kingston History Centre (definitely well worth visiting).

Left: The Old Crown (previously The Chequers) at the rear of which, in the yard, was the well.

B

Dr William Battie

In 1722 Dr William Battie married Ann, daughter of Barnham Goode of Kingston, under-master of Eton School.

He studied law at Eton and Cambridge but failed bar exams. Unable to follow a legal career, he turned to medicine, specifically 'disorders of the mind'. He initially studied under John Munro at Bethlem (Bedlam) hospital but became concerned that the treatment provided there was ineffective, unnecessary and cruel. He left and set up a rival establishment, St Luke's, where he changed treatment of mental illness. He asserted that people should not be detained just so a family can 'remove' their difficult relative from society and that some people could derive benefit from time in an institution. He proposed that madness was 'as manageable as many other distempers' and divided into 'original' and 'consequential', a forerunner to 'organic' and 'functional' used today.

Battie had his moments. He designed a three-storey house but forgot the staircase and built it on a flood plain, resulting in the ground floor being regularly under water when the Thames flooded. He often dressed as a workman to surprise friends. He then angered bargees of Marlow by suggesting that barges be hauled by horses not men. When then confronted by a mob he did a dancing impression of Mr Punch.

He alienated a number of fellow 'professionals' with his treatment methods and was often ridiculed and scorned. His 'Treatise on Madness', advocating humane treatment with reassurance, cleanliness, good food, support from friends and family and caring management, is looked upon today as the first significant work of modern psychiatry.

William Munk, at the Royal College of Physicians wrote, 'He was eccentric in habits, singular in his dress, sometimes appearing like a labourer, and doing strange things. Notwithstanding his peculiarities, he is to be looked upon as a man of learning, of benevolent spirit, humour, inclination to satire, and considerable skill in his profession.'

Informed sources state that the origin of 'batty' meaning eccentric or mad was first used in 1903 referencing having 'bats in the belfry'. However, his name, strange behaviour and treatment of mental illness suggests, to me at least, that people may have thought, much earlier than 1903, 'Battie by name ...'

He was buried in All Saints' churchyard, his instructions being 'as close as possible to my wife and with no headstone'.

A
TREATISE
O N
MADNESS.

By WILLIAM BATTIE M. D.

Fellow of the College of Phyſicians in LONDON,

And Phyſician to St. Luke's Hoſpital.

L O N D O N:

Printed for J. WHISTON, and B. WHITE, in Fleet-ſtreet.

M,DCC,LVIII.

[Price Two Shillings and Six-Pence.]

The birth of modern psychiatry?

Bentall's

It could have been so different. Had Frank Bentall, a draper's son living in Essex, not wanted to expand his knowledge of drapery and become apprenticed to a silk mercer in Southampton; not gone to church twice each Sunday; not become involved with the Sunday school; not met Laura Dowman there; and had Laura's father simply accepted him being a lowly draper's assistant, then Frank may not have reacted as he did on hearing, in 1867, that James Hatt's draper's shop, at No. 31 Clarence Street, Kingston, was for sale.

Believing that he was ready to become a draper and wanting to demonstrate to his potential father-in-law that he could care for Laura, Frank acquired the shop, helped financially by his father. Fortune smiled. Two years later Kingston had a new rail link with London, via Wimbledon, supplementing the existing link with Waterloo, via Twickenham. The following year bridge tolls were removed and traffic passing the shop increased.

Frank was customer-friendly in attitude and business and, as there were more than twenty other draper's stores in the town, he focused on reliability and good service. He took care of his staff and, in 1868, he and other drapers closed their shops on Christmas Day and Boxing Day, before it was a public holiday. With 27 December being a Sunday, this gave staff an unprecedented three-day holiday.

In 1893 Frank's second son, Leonard, joined his brother and father in business. Frank had built a successful enterprise but it was Leonard's foresight and acumen that saw the shop soar and achieve 'Department Store' status, rivalling any in London's West End. Between 1935 and 1976 Bentall's of Kingston was said to be the largest department store in the UK outside Central London.

Leonard purchased No. 27, an outfitter and bootmaker, and then the corner Baker's and Confectioner's shop of Emma Lewis at No. 25 which, significantly, had a window in Clarence Street and in Wood Street, the door being on the corner. He then persuaded the adjacent school to relocate, at his expense, by building a new school building.

He introduced the American concept of 'replacement or a cash refund' for an unsatisfactory item, one of the first stores in the UK to do so. He offered a free delivery service within 20 miles, items being conveyed by horse-drawn vans. Pattern books were issued freely to anyone on request and the nightwatchman was tasked to take telephone orders when the store was closed.

In 1907 he introduced automatically opening doors, electrically lit the basement and negotiated a cheaper rate of electricity during the then 'off-peak' daytime period. When this was later withdrawn he installed generators and, making use of 'his' electricity, installed a variety of electrically operated equipment: machines for opening post, measuring cloth, calculating; electric windows, ventilators and sun-blinds;

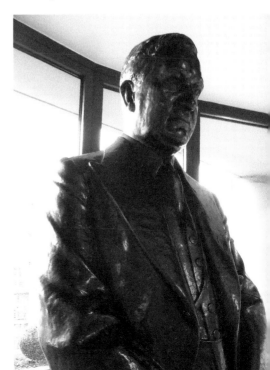

Leonard Bentall – the man who made Kingston.

he installed a pneumatic cash system with overhead brass tubes shuttling cash and change to and fro; flashing lights (each having a different meaning) alerted staff; and he commissioned the first electric escalators to be installed in a UK department store.

Leonard foresaw the importance of the car for shopping and built a 450-space car park; he opened a restaurant for shoppers and the public; he established a staff welfare clinic, bonus scheme and death benefits; and promoted a family allowance scheme for families with more than two children. Unconventionally, he imposed a complete ban on staff smoking on the premises.

Leonard was later called, justifiably, 'The Man who made Kingston'.

But yes, it could have been so different. When James Hatt was selling his draper's shop, the grocer next door was selling his shop to Henry Lewcock, another young draper hoping to establish himself in Kingston. By 1881, Henry had turned away from drapery and sold mineral waters.

Dr Daniel Biddle

Dr Daniel Biddle was, for fifty years, a local GP and house-surgeon at St Thomas's Hospital, London, specialising in respiratory illness. A well-known mathematician, he was mathematical editor of the *Educational Times*. He loved statistics and, in 1885, was asked to assist with a statistical report to the General Medical Council and was credited for his detailed, diligent approach. He helped form the Thames Valley Medical Association and was keenly interested with the BMA.

Kingston seems to have an affinity with conquering the air. Thirty years before the arrival of Clarke or Sopwith, Biddle was tackling the concept of steering manned balloons. By summer of 1875, he believed he had an answer and filed his design, being assigned provisional patent application (No. 2901) for 'an improved method of and apparatus for steering balloons'.

Unfortunately, his invention didn't take off. Undaunted, he set his mind to harnessing tidal power, writing many articles on the subject. He also published a system of shorthand and was a strong supporter of legalising marriage to a deceased wife's sister.

He regularly corresponded to journals and became a published author, his books examining, in a thought-provoking, unbiased manner, theological debate which critics praised and condemned in equal measure depending upon their personal

A.D. 1875, August 17.—No. 2901.

BIDDLE, DANIEL, of Kingston on Thames, in the county of Surrey, surgeon.—" An improved method " of and apparatus for steering balloons."

The apparatus, which is capable of being attached to an ordinary balloon, consists essentially of a large triangular sail placed between the car and the bag at an oblique angle with the horizon ; and of a rudder projecting beyond this sail, and rotating upon a horizontal axis. The large sail is reversible so as to present a concave surface to the resistance of the air during both ascent and descent. It is also capable of being readily furled.

Biddle's patent description for controlling balloons.

Biddle's home in Grove Crescent.

convictions. His work 'The Spirit Controversy' examined whether one's soul is immortal – a question and concept still worthy of debate.

His obituary states that he 'retained the esteem and affection of his many patients', but perhaps not fellow authors whose work he criticised. Commenting on a fellow doctor's work, he wrote, 'Dr Churchill's book contains the advocacy of secret ... remedies. Such a book, no doubt, finds its natural place – when it is thrown away.'

Bishops' Hall

Between 1538 and 1543, the 'father of local history', John Leland, is believed to have visited Kingston. Whilst he likely wrote in Latin, a 1744 translation advises that:

> In the new Toune by the Thamise side there is a House yet caullid the Bishopes Haulle. But now it is tournid into a commune Dwellinge House of a Tounisch Man. It was sumtyme the Bishop of Winchester's House: and as far as I can conject sum Bishop, wery of it, did neglect this House, and it becam to build at Asher nere the Thamise Side 2 or 3 Miles above Kingeston.

Until recently this was the earliest published reference to the hall and has led to subsequent conjecture and definitive statement that the Bishops of Winchester had a 'Palace' here. However, recently published accounts of the Manor of Esher shed

light on the hall between 1257 and 1336, showing that it was leased by the manor and received annual rent for the hall and an accompanying plot of enclosed land.

Accounts show that the Bishops of Winchester expended monies on repair and upkeep to try to secure the annual rental, which, in 1258, was 20s (£1,000) with 5s collected quarterly.

The hall appears to have been built alongside and parallel to the river and had its own quayside. In 1268, accounts record that its kitchen was replaced and a new kitchen, larder and room for making sauces provided. Thomas Carpenter and his three men were paid as a team a daily rate of 14½d (£50). The new rooms were roofed and tiled and the hall roof was repaired. Timber comprised oak and beech. The timbers were sawn on the quayside, which was later enclosed and filled in with earth and heather. The hall had a small outer chamber.

In 1317, the manor only received a tenth of the rent as the hall was not in a fit state. It was occupied by the Sheriff of Surrey, on behalf of the King, for storing wooden shingles for 'the great hall of Westminster'. This is an interesting association with Kingston and the Great Hall, eighty years earlier than previously known.

In 1320 and 1326, accounts record 2s annual rent for the hall 'because it was unroofed and broken down because no one wanted to hire it'. By 1332 rental for the hall had ceased. Reference is solely made to leasing of a plot of land with a curtilage for 2s, suggesting that the building has either been demolished or is considered unusable.

The accounts provide a clue to how the hall was used. Fines are received from brewers, including aptly named John le Brewer of Kingston, for the breaking of the 'assize of ale' where beverages were being sold above the regulated price. When taken with reference to the kitchen etc. this suggests that the hall was a place of wining and dining. Wakeford advises that a tenant, Thomas Herland, a beer brewer, is said to have entertained Henry V here in 1414.

It is conceivable that Thomas was related to Richard II's chief carpenter Hugh Herland, who, Sampson tells, lived in Bishops' Hall from 1392. On 17 October 1396, Richard granted to Herland 'all of the croppings and coppices from trees and timber provided for the hall within the Palace of Westminster and other the King's works which lie ouit and remaining over in a wood near Kyngeston-on-Thames'.

Bloody Dick

Whatever Bloody Dick did is lost to time, but when Richard Smith's burial, 20 August 1680, was entered in the parish register, someone felt compelled to record his eke-name alongside ('eke' from the Anglo-Saxon 'eaca' meant 'to increase' and so an 'eke-name' originally meant an 'additional name' which became corrupted by pronunciation, with the 'n' moving across to become 'a neke-name' from whence 'a nickname' comes), so it must have been very significant – almost as if the entry was to reassure people that Bloody Dick was indeed dead and they need fear him no more.

C

Donald Campbell CBE

Donald Malcolm Campbell CBE, born at Canbury House on Kingston Hill in 1921, had a lot to live up to being the only son of Sir Malcolm Campbell, growing up and always hearing of his father's exploits and achievements. Sir Malcolm had a love for speed; he raced at Brooklands, won three motorcycle road races, won the French Grand Prix in 1927 and 1928 and between 1924 and 1935 became the fastest man on land nine times and was the first man to travel over 300 mph. He also broke four water speed records, the last being in August 1939 on Coniston Water, Cumbria, a year after which he became divorced from Donald's mother.

Donald was sent to Uppingham School, following his father. When war was declared he tried to enlist in the RAF, again following his father's footsteps, but, when refused for health reasons, became a maintenance engineer.

After his father's death in 1948, Donald set about becoming the fastest man on water, initially using his father's boat, *Blue Bird K4*, but, seeing limitations, he developed his own boat and streamlined the name into one word as *Bluebird K7*. Seven times he successfully reclaimed the water speed record as it rose from 202 mph to 276 mph. His *Bluebird K7* was regularly seen in Kingston and New Malden using the haulage company Adams and Adams to transport the speedboat.

The Campbells'
home, now
Canbury School.

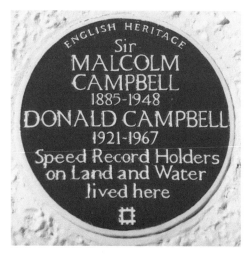

Like father, like son!

Donald remained in the shadow of his father until 17 July 1964 when, at Lake Eyre, Adelaide, he achieved 403 mph on land. His seventh and last reclamation of the water speed record, on 31 December 1964 in Western Australia, meant he was the first man, and today remains the only man, to have claimed land and water speed records in the same year. For a time he was the fastest man on land and water.

In 1967, he returned to Coniston Water, the scene of his father's last record success, to reclaim the water speed record. Targeting 300 mph, *K7* averaged 297.6 mph with a maximum speed of 310 mph on the first run. Donald turned and on his fateful second run was measured at 328 mph, before *K7* hit the wake of the earlier run and somersaulted, the image indelibly printed in the memory of anyone who has seen his attempt.

The iconic name 'Blue Bird' came from a play that Sir Malcom once saw in The Haymarket Theatre, London. It refers to the Blue Bird of Happiness, implying that true happiness lies in the warmth of family life. Iconic and ultimately ironic at the same time.

Clattern Bridge

The great thing about history, for me, is that there is always something more to be unearthed and whilst accepted knowledge thus far for the bridge covers its construction, age, widening and origin of its name, I wonder if, like me, you'll be surprised to read that in the late seventeenth century it was gated, had ledges with posts and chains each side and the roadway regularly covered in gravel.

Chamberlains' records tell of a gate lock and two staples for Clattern Bridge in 1676, again in 1684 and then a Mr Malo is paid in 1698 for two locks.

Aubrey tells us that 'there is a bridge call'd Clathorn, built of brick, that rises up high like a high nose'. This could easily have caused problems for cart wheels to grip and accounts in 1701 of laying gravel on Clattern Bridge are quite understandable. Over the years since then the bridge has had a 'nose job' with the road level each side flattening out the arch.

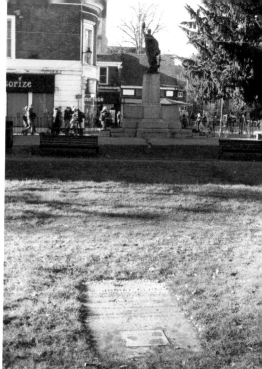

Above left: Clattern Bridge no longer looks like a nose, and many drivers don't realise it is even there!

Above right: Josiah's resting place.

Lieutenant Josiah Clues

'What links Kingston with Waterloo?' No, not the railway! Kingston is the last resting place of Lieutenant Josiah Clues, who served under the Duke of Wellington at Vittoria, Pamplona and Waterloo.

His gravestone, the only one in the grassed area behind the war memorial, tells that he was Adjutant of the 2nd Life Guards at the Battle of Waterloo but he had actually been promoted to 'Cornet' on 12 April 1815 and he was of vital importance to the Life Guards during the battle, his role being to stay close to the commanding officer and carry the standard on which the cavalry would rally. The enemy prized finding a Cornet as capturing the standard prevented troops rallying and meant that an enemy commander was close by. Many Cornets lost their life, but Josiah was lucky.

Clues would have been involved in one of the decisive actions of the battle where, mid-afternoon, the French were breaking through the allies' centre and needed to be stopped otherwise all was lost. The Household Cavalry were ordered to charge and thwart the advance.

Initial triumph led to foolhardy over-stretching and then to disaster, as the regiment was surrounded by Cuirassiers and Lancers and had to fight its way back following Cornet Clues and others. When the regiment rallied, three of every four of the original contingent had not returned but, crucially, Wellington's centre had been secured.

Clues was promoted to Lieutenant in October 1816 and retired on a pension of half pay for life three months later, at the age of thirty-seven. In 1841, aged sixty, Josiah was living in (Middle) Mill Lane on 'half pay' with wife Esther. He died the following year and was buried in the All Saints' Church overspill burial ground, now Memorial Gardens.

The Cocoanut

Reputedly the only pub in the country called 'The Cocoanut' is in Mill Lane, south of the Fairfield. The road recalls the importance of the Hogsmill River, which once powered mills from Ewell to Kingston. Originally flour mills, diversification led to upstream gunpowder mills. Of the three mills closest to Kingston, by the late eighteenth century, Chapel Mill (site of a waste depot today) pounded linseed flax to extract oil and marketed flax cake waste, for fodder, as a 'by-product'.

In the 1840s, Middle Mill was acquired by the Patent Cocoa Fibre Company, and fibre, separated from coconut husks, was used to make brushes and coir mats.

The company exhibited at the Great Exhibition (1851) and the International Exhibition at South Kensington (1862). Owned by solicitor Edmund Hyde, the ingenuity came from John Barsham of Chelmsford and his 1849 patent for separating fibres using crushing and combing rollers.

As with Chapel Mill, having a successful 'by-product' of the waste was key and horticulturalists found that the 'pulp' refuse, from the rollers, was beneficial for growing ferns and potting and coir is still used for such being a sustainable alternative to peat.

The company advertised its 'refuse' and exhibited it separately to their brushes. Magazines stated that Middle Mill was the only place in the 'three Kingdoms' where coconut refuse could be obtained. It appears that Barsham's machinery and the 'by-product' were only successful on the Hogsmill.

With the success of the brushes the refuse pile grew and adverts previously offering it 'by the bag' later offered it 'by the train truckload'. In addition, there were growing mounds of stripped coconut shells, but you'll have to wait until later to see what they did with them!

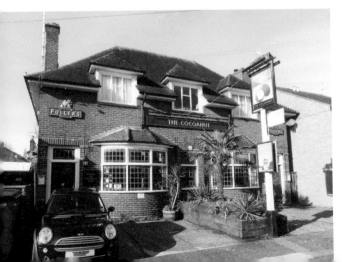

The Cocoanut public house.

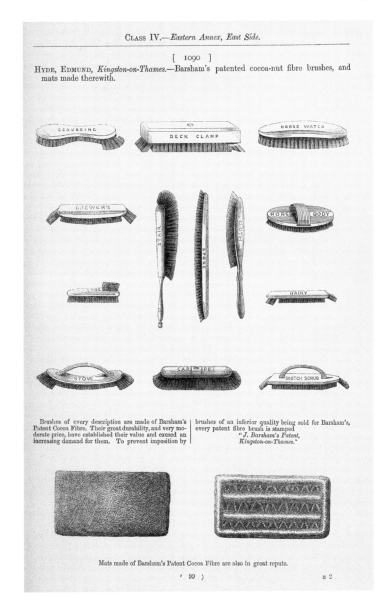

[1090]

Hyde, Edmund, *Kingston-on-Thames.*—Barsham's patented cocoa-nut fibre brushes, and mats made therewith.

Brushes of every description are made of Barsham's Patent Cocoa Fibre. Their great durability, and very moderate price, have established their value and caused an increasing demand for them. To prevent imposition by brushes of an inferior quality being sold for Barsham's, every patent fibre brush is stamped "J. Barsham's Patent, Kingston-on-Thames."

Mats made of Barsham's Patent Cocoa Fibre are also in great repute.

(90)

II 2

The range of Barsham's brushes produced at Middle Mill.

The company tried to secure funding for improvement but, by 1876, Edmund Hyde had retired and the company was wound up. Only the local pub name now bears witness to this long-forgotten industry.

Sampson notes that, in 1867, when the Middle Mill was at its peak, the *Surrey Comet* reported that at Kingston's 'Pleasure Fair', relocated that year to the Fairfield, 'for the small sum of one penny, you could have three throws with sticks with the prospect of getting a cocoa-nut'. The fairground game of throwing sticks at poles to dislodge something and win a prize had been recorded in 1804 by Rowlandson but it is intriguing to think that surplus coconuts from Middle Mill could have provided

the first press-recorded fairground Coconut Shy. Incidentally, you could also win a coconut if you managed to throw a ball into a 'gaping mouth'. On winning a coconut you were assured by the stall owner that you could 'crack it and try it'.

Crack Nut Sunday

On 'Crack Nut Sunday', the Sunday before Michaelmas, churchgoers of all ages attending All Saints' would carry nuts into the church and crack them loudly during the service. Brayley advises that the 'cracking noise was often so powerful that the minister was obliged to suspend his reading, or discourse, until such time that a greater quietness was obtained'. He continues that 'of the origin (of the custom) nothing has been ascertained and its practice has, by 1844, falling into desuetude following an effectual stand against its continuance by the church officers having been made about sixty years ago'.

However, I believe the custom was directly associated with one of St Michael's four offices, that which requires him to fight Satan. I see a direct parallel with the Jewish celebration 'Purim' whereby the name of evil is met with noise of wooden hammers, rattles, hissing, cursing and the stamping of feet that would not be tolerated in a house of prayer at any other time. It seems that there was a belief that evil cannot tolerate noise.

Nuts would be readily available on 29 September, the festival of St Michael and all Angels, but two weeks before this is Holyrood Day (14 September), the day said to be the best day for picking nuts. The old saying 'the Devil goes nutting on Holyrood Day' led to unchaperoned young women being warned that they may meet the Devil, in the form of a man, pulling down branches of a nut tree to help them.

Collecting nuts on Holyrood Day, when the Devil was a-nutting, and later cracking them in church could well have been a show of defiance to the Devil and religious 'solidarity' with Arch Angel St Michael, in effect, saying 'Nuts' to the Devil.

Go 'a-nutting' at Tony's fruit stall in the Market Place.

D

Dan Dendy

Dan was a Watchman, an official guardian of public safety before the Metropolitan Police took charge of the town in January 1840. His beat was London Road to Norbiton Hall, opposite Coombe Lane, just north of which stood the old workhouse.

Part of Dan's job was to 'cry the hour', assuring people that 'all was well'. However, it was said that he had a strange voice and few could understand him. Merryweather tells of Bill Bird, a partly deaf workhouse inmate who relied on the watchman to tell the time so he could repeat it for the workhouse.

Bird once exclaimed in frustration with Dendy, 'Drat that Watchman! I can't hear what he says. How can I cry the night? It don't rain, it ain't moonlight and the stars don't shine and, dang it, how can I tell what sort of night it is?'

Despite the fact that many considered the Watchmen to be useless, sleeping soundly in their watch boxes and, when they saw a thief, letting him go, the arrival of the Metropolitan Police was not immediately received favourably.

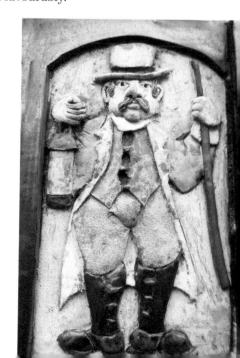

Eden Street mural depiction of a 'Watchman'.

Dope

Without dope any fabric-covered aeroplane would soon be in trouble. Invented in Germany, the cellulose-based lacquer renders the fabric waterproof and airtight, by shrinking the loose material to fit tightly to the frame.

In 1911, Alexander Barr was offered an opportunity that would later change Britain's and the world's fortunes: the British patent to develop dope. Initially, he made small quantities in Clapham and sold this to nearby aviation pioneers the Short Brothers, whose success led to other orders. Pioneer constructors, British and Colonial Aeroplane Co. (Bristol), AV Roe, SF Cody, Sopwith and Blackburn all sought and used his dope, which he eventually marketed under the name Cellon.

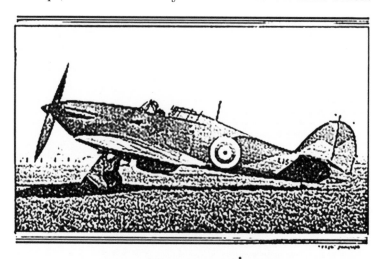

The selection of Cellon Finishes for the new Hawker Hurricane Fighter adds yet another to the long list of high performance Aircraft to receive Cellon protection. Whenever exceptional stresses or arduous wear and weather are to be resisted, Cellon Finishes may be relied upon to demonstrate their quality.

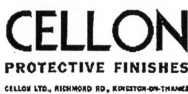

PROTECTIVE FINISHES

CELLON LTD., RICHMOND RD., KINGSTON-ON-THAMES

The importance of 'doping' and its contribution to winning the Battle of Britain is often overlooked.

The outbreak of the First World War saw German supplies of cellulose acetate cease, but a French company guaranteed supply and, throughout the war, Barr was flown, by special RFC permission, to and from Paris to secure the base ingredients.

He acquired a factory in Richmond (later home to the Poppy Factory) but when, in 1927, this proved to be too small to meet post-war requirements, he acquired a 5-acre site (today St George's retail park) where Cellon and derivatives were made.

The company also patented a process for covering rivets by means of metal strip applied by an anti-corrosive thermo-setting adhesive, which led to the process being widely used in the Aircraft Industry between the wars. Cellon was used by the Supermarine Company for its Spitfire speed tests and its resistance to saltwater corrosion assisted the fighter's high speed and securing of the Schneider Trophy.

Cellon protective finishes were applied to armoured fighting vehicles, motor torpedo boats, landing craft, and for camouflaging buildings. The greatest testament to Barr is that his Kingston-made dope was used on Hurricanes, Spitfires, Blenheims, Wellingtons, Mosquitos and Lancasters, without which the world would be a very different place.

Ducking Stool

Sitting tradesmen, found to have defrauded their customers, in their own excrement, and immersing women having a nagging, unruly tongue were originally Saxon punishments but both were practised in Kingston into the eighteenth century.

Over time, two separate contraptions for the punishments became one and the name of the former, the 'cucking stool', corrupted and became associated with the latter, the 'ducking stool'.

'Cukkyn' meant 'to defecate' and so, politely, the 'cucking stool' meant defecating stool (pun not intended) and its aim was to humiliate and degrade, more so than static stocks, pillory or the sedentary 'cuck chair' as, by adding wheels, the transgressor could be wheeled around for all to see. The stool acted as a deterrent and was often wheeled to a future candidate's house as a distinct warning of impending use.

Following such humiliation, the stool and its occupant understandably needed cleaning, achieved by employing immersion in a nearby river, which was visually enjoyable. In view of the crowds that would gather, it's likely there was a movement towards ducking as the common punishment and the motion was carried.

Chamberlains' accounts, 1572, record expenditure of 8s (£100) for the making of the 'cucking' stool and 15s 4d (£200) for materials, including three wheels. Churchwarden accounts tell that the stool was soon in use:

> 'On Tewsday being the xix day of this month of August ... Downing wife to ... Downing gravemaker of this parysshe she was sett on a new cukking stole made of a grett hythe and so browght a bowte the markett place to Temes bridge and ther had 111 Duckings over hed and eres becowse she was a common scolde and fighter.'

Note the use of both cucking and ducking, the stool clearly had dual use at this time.
In October 1738, the Universal Spectator reported:

> Last week at the Quarter Sessions at Kingston-upon-Thames, an elderly woman, notorious for her vociferation, was indicted for a common scold, and the facts alleged being fully proved, she was sentenced to receive the old punishment of being ducked, which was accordingly executed upon her in the Thames, by the proper officers, in a chair for that purpose preserved in the town; and to prove the justice of the court's sentence upon her, on her return from the water-side she fell upon one of her acquaintance, without provocation, with tongue, tooth, and nail and would, had not the officers interposed, have deserved a second punishment even before she was dry from the first.

Seven years later, the *London Evening Post*, on 27 April, reported:

> Last week a woman who keeps the Queen's Head ale-house at Kingston, in Surrey, was ordered by the court to be ducked for scolding, and was accordingly placed in the chair, and ducked in the river Thames, under Kingston bridge, in the presence of 2,000 or 3,000 people.

Ducking did not take place from the Thames or Clattern bridges but at the sloping banks alongside the rivers where the stool could easily be wheeled in and out.

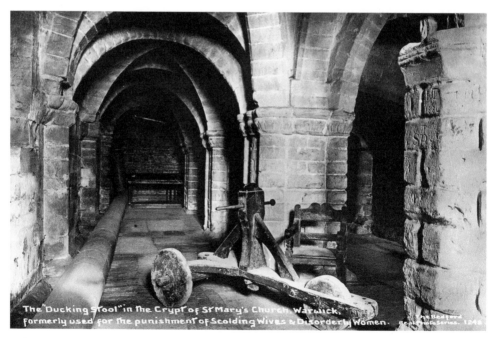

A three-wheeled stool. Kingston's cucking stool is believed to have been similar.

East Surrey Memorial Gates, Chapel and Colours

The gates, chapel and regimental colours (the flags) at All Saints' Church are a memorial to servicemen from Surrey and, historically, men from Huntingdonshire. The East Surrey Regiment formed in 1881 as military reforms sought to provide regional 'depots' where local men could enlist, be trained and be barracked. Single-batallion regiments without a specific home were amalgamated and the 31st (Huntingdonshire) and 70th (Surrey) Regiments of Foot joined and became based at Surrey, being joined by Regiments of the Royal Surrey Militia.

In 1920, the Holy Trinity Chapel of the church was refurbished by the Regiment to serve as a war memorial to the officers and men of the East Surreys and reopened in 1921.

The military colours displayed therein are known as 'a stand' and always comprise two flags: the Royal Colour, always paraded on the right, based on the Union Flag; and on the left, the Regimental Colour, carrying the Regiment's battle honours, which can only be awarded by the Sovereign.

> A moth-eaten rag on a worm-eaten pole,
> It does not look likely to stir a man's soul,
> 'Tis the deeds that were done 'neath the moth-eaten rag,
> When the pole was a staff, and the rag was a flag.

Colours evolved in the late seventeenth century as a rallying point in the smoke of battle. All needed to know what to 'look for' when rallying and a junior officer, an 'Ensign', would march the colours through the paraded troops before battle so the rallying point could be later recognised. This is the basis of 'Trooping the Colour'.

The memorial gates, unveiled on Armistice Day 1924, complete the 1914–19 war memorial to the East Surreys, the other part being the chapel. Over the gates is the Regimental Badge, with the star of the Order of the Garter united with the arms of Guildford, a three-towered castle. Flanking the castle are two woolpacks signifying

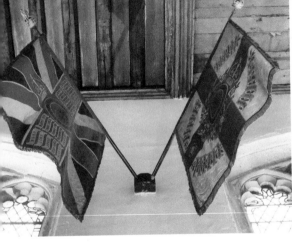

A 'Stand' or just two moth-eaten rags.

Part of the memorial dedicated to the
East Surrey Regiment.

Surrey's wool-producing heritage. In recognition of Kingston Barracks, a shield with the town's heraldic arms of three silver salmon on a blue background has been incorporated in the display.

Eden Street Mural

Commissioned in 1984 by the Royal Borough, it comprises sixty-seven pieces of stoneware clay sculpted by Maggie Humphry, whose name appears on the bow of the boat on the Thames.

The mural should be read in three separate sections: the top depicts, chronologically, the seven Anglo-Saxon kings whose coronations are believed, by some, to have taken place in Kingston (though there is only evidence for Athelstan and Ethelred being crowned here); the second section depicts the River Thames, the trading highway of the town, and images relating thereto; the third section, comprising a number of images is, for me, the most interesting section, yet the mural carries no explanation.

Kingston octogenarian George Ayliffe kept notes and in 1914, having recounted stories of residents and buildings in the *Surrey Comet*, the articles were published.

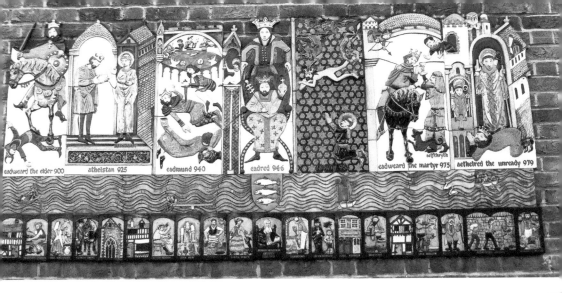

Above: A stunning creation which would benefit from an accompanying description.

Right: A Humphry self-portrait perhaps?

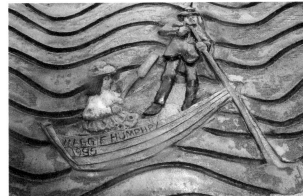

Humphry referenced the book of his stories ('Old Kingston') and the lower section depicts her images of past residents of Eden Street, previously known as Heathen Street, leading to Giggs Hill at the bottom of the Apple Market.

Left to right: the 'Hand and Mace' pub, which contained the Debtor's Prison and led to wags saying that it was the only place in Kingston where beer was sold 'by the pound'.

William Pitman was a 'ladies' shoemaker who was always on the point of receiving a fortune, which never arrived'. Mrs Billingah was a 'noted midwife' who lived next door to Thomas Emms, a 'celebrated veterinary and shoeing-smith, a leading spirit at all social functions and an excellent horseman'.

St Mary's Chapel is followed by an image of a stonemason but which is not clear as Ayliffe tells of two. Mrs Cowley's was next to Hodgson's Brewery on the corner of Brook Street and another separated the old Congregational Chapel from John New, fishmonger, who 'every morning in a peculiar fish cart, started at two o'clock for Billingsgate Market, returning with his fish between eight and nine o'clock'. The butcher is probably Richard Paine and Sarah Pratt was a lady of independent means.

John Slawson, the baker, then John Rowles, 'a noted chimney sweep' who was 'a model employer who fitted up hot and cold baths for his climbing boys whom he clothed, fed and educated well and took to church every Sunday'.

Will Herrick and the Three Compasses is followed by Fricker's Cooperage, which stood on the site of Eagle Chambers. Ralf Coulson, an eccentric painter, always carried a big stick and engaged a fiddler to play at his front door. Charlie Hanks was a 20-stone watchman. The Bridewell Prison was where the old Post Office stood and Mr Charles White Taylor was a grocer.

There is currently talk of the work being taken down prior to redevelopment of Eden Walk. Hopefully it will remain in Eden Street where it belongs.

Engine

Chamberlains' accounts, for the end of the seventeenth century, record monies expended to Robert Adams for keeping and repairing 'the engine' and 'spent on ye men and players of the engine' but don't say who was 'playing' what?

As years pass, different parties become responsible for its care but there are no more details until the 1689 reference to providing leather and 'for making a tub for the engine'. Further references record the 'playing' and mending the pipe of the 'great engine'.

At the turn of the eighteenth century Robert Adams is again keeping the water engine and all becomes clear in 1702 when monies are paid out 'to four men for bringing back to Mr Souths after the fire which happened in Norbiton' and to 'Mr South's and Mr Chamberlain's men to drinks when the engine was mended and played'. Mr Chamberlain is later identified as being 'the plumber'.

Therefore, as early as 1670, possibly earlier, Kingston had a 'fire engine' which needed regular care, attention and 'playing'. However, there was no 'fun' involved as the verb is used in the sense of 'bring into play' or 'operating'.

Executions

Treason and heresy were visibly punished in the town, whereas the more common crimes of murder, theft, indecency, forgery, etc. were punished at the gallows on Kingston Hill, beside the road leading to and from the town, opposite today's Kingston Lodge Hotel.

Thomas Denys, head of a Malden-based heretical Lollard ring, was burned in the Market Place for heresy on 6 March 1513. Previously tried and having recanted, Denys was executed for having relapsed. Other Kingston Lollards – Phillip Braban, John Langborowe and Margery Jopson – escaped burning as they had not previously been tried but were forced to watch and commanded to throw their heretical books into the fire as Denys suffered.

William Way knew the punishment that practising as a Roman Catholic priest in Elizabeth's Protestant England carried but continued. Incarcerated in the Clink Prison, Southwark, he declined to be tried by a secular judge and refused to acknowledge the Queen as head of the Church. This sealed his fate, a traitor's death, but on sentencing

Extract from Rocque's 1746 map, showing the triangular gallows opposite the Fox and Coney, today the Kingston Lodge Hotel.

he was 'past himself with joy' at the prospect of becoming a martyr. On 23 September 1588, six weeks after the threat of invasion from the Catholic Armada, he was hanged, had his intestines 'drawn out' and was quartered in Kingston. The location is not known but the Market Place seems likely.

Chamberlains' accounts for 1681 record 'thirty-three foot of timber to make the gallows' and 'one hundred of bavins and fifty faggots to burne ye woman'. On 16 March 1681, the Market Place saw Margaret Osgood executed, by burning, for killing her husband to whom by law she 'belonged'. Her crime was therefore 'petty treason', not murder. The account of her execution suggests a delay in lighting the fire and it is likely that, as a mercy, she was strangled before the fire was lit. Burial records for that Sunday state '7 men and a woman hanged, and one buried'. The 'one buried' perhaps is referring to Margaret's 'remains'.

On 23 July 1692, Robert Benneson was hanged for 'clipping', which was the trimming of silver from the edges of coins. William III introduced the Window Tax in 1696 to combat clipping losses. Coins subsequently had milled or patterned edges so one could see if it had been clipped.

In 1724, the timber gallows of 1681 on Kingston Hill was replaced and on 4 April, the new triangular 'tree' was put to a vigorous test, as accounts advise: '13 criminals executed at new gallows'.

The gallows stood beside the road just beyond the 1936 boundary marker for the Borough of Maldens and Coombe.

Fish Market

Regular payments were made throughout the sixteenth and seventeenth centuries for sweeping, cleaning and whipping dogs out of the fish market. Strangely though, we cannot say for certain where the fish market was located. Widow 'goodie Gates' provides a clue as she was paid in 1690–92 for sweeping the fish market. In 1693, she was paid for sweeping 'under the Court Hall' but from 1696, the Chamberlains' accounts revert back to her sweeping and cleaning the fish market.

It seems that the old, stilt-mounted Town and Court Hall provided cover for other pressing daily activities but for these you will have to wait for a P.

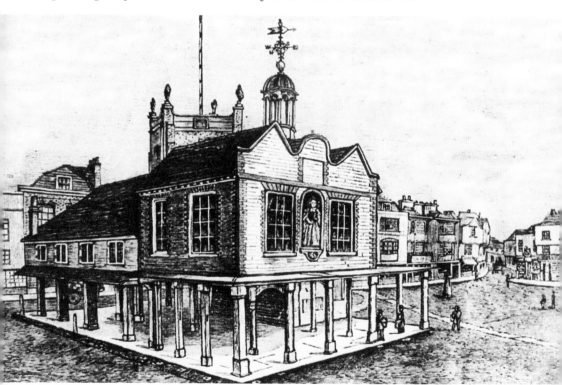

The old Town Hall with paved 'covered market' beneath.

Football

'Annual Shrovetide Football': Shrove Tuesday, 11am to 5pm, starting at Market Place, thereafter 'unknown'. Rules: 'flexible'.

The earliest reference to football being played in Kingston is from the *Surrey Advertiser*, 5 August 1939, which advises that a print of the Shrove Tuesday football in Kingston Market Place in 1775 had been destroyed in a fire at Kingstonian FC.

The *Illustrated Times*, 28 February 1846, provides the earliest reference to teams the Thames-Street Club and Towns-end and the 'rule' which is 'to kick the ball throughout the town and whichever team gets the ball nearest the meeting-place at five o'clock, wins the game'.

Preparations took place in the hours before the game. Flags and streamers were unfurled, windows barricaded and a gilded ball hung on a flagpole from the window of the Druid's Head or the Coach and Horses inn (currently 'Lush').

People assembled just before 10 a.m. and, with music from 'Duffell's Band', a procession led by the Master General of the Football, bearer of gilded balls held aloft and suspended from a pole with streamers, entered and paraded around the assembly. The parade traversed the town returning shortly before 11 a.m. A cask of ale would be presented and drained by the 'players' who would then separate into their two teams. Following the national anthem being sung, all would eagerly await the tolling of the 'Pancake Bell' in the church tower at 11 a.m. On hearing the bell, a leading town figure, often but not exclusively the mayor, kicked the first ball into the crowd.

Press descriptions vary over the years but, generally, someone would catch the ball from the kick-off and 'hug' it to his chest; others would hug him and others them, and the throng would gradually move along. Rather than being suffocated, the holder soon released the ball and the inflated animal's bladder surrounded by stitched leather would reappear, the gilt having worn off.

Despite the term 'football', the ball would be 'hugged', often into inns where it, and undoubtedly players and followers, would be 'wetted' before being thrown out of the window to continue around the town. One year the ball was seen to go via Thames Street, Clarence Street, into the police yard in London Road, back to Eden Street, into the brewery yard at the corner of Brook Street and down to Clattern Bridge. In 1862,

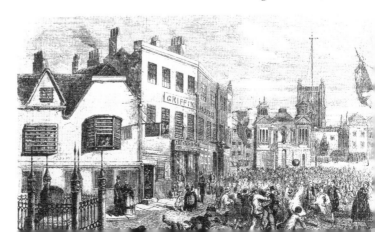

Attack and defence at
Town End.

the *Surrey Comet* reports it going beyond Clattern Bridge and believed to have been kicked past Surbiton to Long Ditton.

On another occasion, with the river level to the top of the arches of the bridge, the ball entered the Thames and a player jumped from the parapet to retrieve it. He was carried by the force of the river through an arch but was safely rescued on the other side, and the game continued.

At 5 p.m. the 'Pancake Bell' would ring again. The game would immediately cease, the winning team was agreed and 'bragging rights' for the year established. After the national anthem people would depart, generally as friends. A dinner would be held at The Griffin for the dignitaries and the inns and pubs would host the other participants and the onlookers.

In February 1860, the *Surrey Comet* recounted a tale of apparent mistaken loyalty. Police came from Richmond to watch the 'game' from the Sun Hotel. One officer bore considerable resemblance to the Prince of Wales (later Edward VII). Rumour spread that Edward was attending and Master General of Football, James Lish, called for the band to play the national anthem yet again and went to the hotel to present a football to 'His Royal Highness', but was met with hoots of laughter. However, many remained convinced that their future King had visited the town that Pancake Day.

Despite mayors and aldermen admirably defending the 'ancient' custom in the early 1860s, the game's days were numbered. Horseplay became rough, bags of flour and soot were introduced and authorities decided to end the carnival. A strong faction sought to relocate the game to the Fairfield and this together with the establishment of the Football Association in 1863 – of which, surprisingly, Surbiton FC was a founding member – saw the demise of the Shrovetide game.

The 'final whistle' blew in 1867 when the mayor, Alfred Priest, withdrew corporate countenance and refused to kick off. The game was played, but it was for the last time in the town.

Kingston has had a taste of football glory with Kingstonian FC who, in 1933, beat Stockton 4-1 in a replay, to win the Football Association Amateur Cup. Twenty thousand people filled the Market Place and surrounding streets to see the team and the cup. Captain Frank Macey was capped on four occasions for the England Amateur XI. In 1998/99 and again the following year, the K's won the FA Trophy.

Four Bridges of Kingston

Until 1729, the first bridge upstream from London Bridge was the old timber Kingston Bridge, which suggests that there was both a need for a crossing here and that this was the easiest place to build. Bridge records indicate it standing in the twelfth century but reason suggests that the crossing here predates records. Foundations of the bridge approach ramp, displayed in the basement of John Lewis, indicate there was need of a solid, permanent structure to meet heavy use.

Right: The site of Bow, later Stoney, Bridge which crossed a wide ditch east of the town.

Above: The site of Barre Bridge which crossed the same wide ditch north of the town.

Geological findings indicate that Kingston developed across gravel islands and was once an island settlement accessed by four bridges to the north, south, east and west.

Wakeford presents the phrase 'within the four bridges of Kingston' with reservation but cites references. A fine of 10*s* was incurred in 1669 for bringing brushwood 'within the four bridges' (an obvious concern as the Great Fire of London was just three years earlier) and in 1674, confirming that burning of furze was prohibited 'within the four Bridges of this Town'. Rights to keep livestock on Norbiton Common included persons 'inhabiting within the foure bridges in Kingston'. So where were these four bridges? The Thames Bridge to the west and Clattering Bridge to the south are self-evident. Bowebrigge, referenced in 1383, becomes Stoneybrugge in 1417 and Cross Keys Bridge in the seventeenth century and stood in today's Clarence Street, at the junction with Fife Road, there being an open ditch 2.5–3 metres (8–10 feet) deep. This was the remnant of an old waterway, east of the town, crossing the road at this point. This old ditch ran north, crossing Wood Street and eventually connecting with the Thames.

Today's Skerne Road was previously Lower Ham Road and, before that, Bar Lane. The railway bridge by Friday's restaurant is where there would have been the bridge 'de la barre' over the ditch, later renamed as Barre Bridge.

Free Grammar School of Queen Elizabeth

Since 1904 the Free Grammar School of Queen Elizabeth has been called Kingston Grammar School. The name change, along with the appointment of a new head teacher and procurement of extra resources by a public appeal, saw a reversal in the school's fortunes. (It had been failing to attract pupils.)

In the process was severed direct connection with Elizabeth, whose charter dated 1 March 1561 acknowledged and responded to petitioning of bailiffs, freemen and

inhabitants of the town for a grammar school, by giving to the new governors of the school the Chapel of St Mary Magdalene, adjacent chapels dedicated to St Anne and St Loyes and adjacent land. Seven times in the charter Elizabeth states that the school will be called the 'Free Grammar School of Queen Elizabeth' but Edwardian governors determined that she should no longer be recognised in the school's name. Is it that easy to go against a previous monarch's expressed wishes?

To provide free education and teaching of boys in 'the grammar', Elizabeth gifted, by her subsequent 1564 charter, income from over 80 acres of Crown land and property rents to this effect to the value of £18 9s 7d per year (£4,500). 20 marcs (£3,000) secured the services of a Master and 'Sub Master'.

'The grammar' comprised strict learning of Latin from entry, aged seven, taught by the Sub Master using rote and memory. Once 'prepped', boys aged ten advanced to the Master and, on leaving aged fourteen, had grounding in Latin, Literature (occasionally Greek), Religious Education, Arithmetic, English Grammar, Philosophy and Theatre. Surprisingly, handwriting was not considered 'essential' to education.

Pupils were taught from dawn to dusk and a school 'year' of 2,000 hours was not unusual. This is the equivalent today of being at school for almost fourteen years, from ages seven to twenty-one.

Aubrey, 1673, advised that money had been 'imbeziled' but the school survived and though, in July 1868, its property comprised only 16 of the 80 acres they had been granted by Elizabeth, the school sought to expand from the chapel.

'The Architect', 23 January 1869, announced that a competition was to open on 1 March for the design of a new school and Master's residence in Kingston. The cost was not to exceed £5,000. A June update advised that of twenty-eight designs received, surprisingly few had adopted a basis of Elizabethan architecture.

The foundation stone, dated 1 January 1877, tells that the successful architect was John Loxwood King who, two years later, designed the original Tiffin School (now St Joseph's Catholic Primary School facing the Fairfield) but, more significantly, it faithfully retains the reference to this being Queen Elizabeth's Grammar School.

The circular reference to Queen Elizabeth's, and not Kingston's, Grammar School.

G

Eric Gill

Gill was a great British sculptor and designer. His sculptures adorn BBC Broadcasting House, the Transport for London building at No. 55 Broadway, the Rockefeller Museum in Jerusalem, the Palace of Nations in Geneva and the corner of the Bentall Centre where a pair of his window carvings flanks his Bentall family crest.

Leonard Bentall was not enamoured with Gill's representation of a leopard on the crest and clashed with him publicly in the street. Bentall complained that the tail hung down like a dog. Gill, who was not skilled in animal sculpture and had carved the crest in situ advised, to Bentall's chagrin, that the nature of the stone meant nothing could be done but, to compensate, he would 'add more spots' so the public would know it was a leopard.

Gill courted controversy and his faith did not prevent him from producing erotic art alongside his spiritual-based designs. Look again at the innocuous carvings flanking

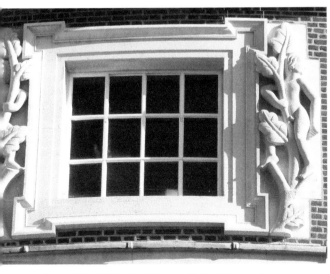

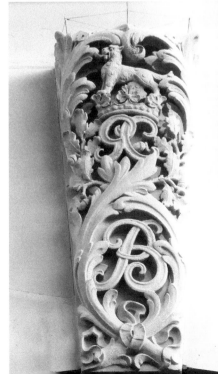

Above: Eric Gill's clutching and climbing nudes are not as innocent as they may appear.

Right: Gill's fine and elaborate over-door 'monograms'.

two windows on the rounded corner. Nude male and female figures cling to, or climb, trunks with large flat leaves suggesting a romanticised forest glade scene. However, these figures closely match Gill's erotic artwork for the *Canterbury Tales* and one particular sketch, *Woman climbing floriated phallus* (1928). Clearly, the erect stalks each side of the windows had a specific meaning in the sculptor's mind differing from that perhaps described to Bentall.

One may question Gill's leopard's tail, his floriated branches and his personal life, but there is no disguising his prowess when viewing the carved initials over the doorways of the Wood Street façade. They are intricate and beautiful.

Golden Jubilee Panel

A panel with over twenty-five images is located in Shrubsole Passage, named after the family whose drapery, undertaking and banking businesses were prominent in the late eighteenth- and early nineteenth-century Market Place.

An illustrated history of Kingston in Shrubsole Passage.

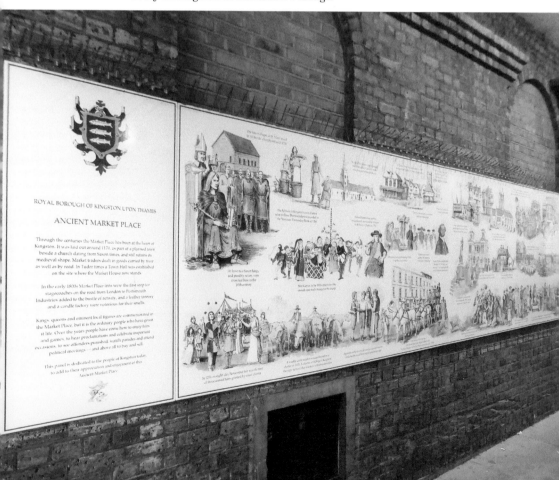

The 6-metre-long and 1.35-metre-high panel depicts important events, people and buildings of the town's colourful history including King Athelstan's coronation, Victorian football, coaching, punishment, fairs and guilds.

Commissioned as a joint venture by the Friends of Kingston Museum and Heritage Service, Kingston Tour Guides and the Kingston upon Thames Society, together with the generous assistance of the National Westminster Bank, Palmers Solicitors, Rowan Bentall Charity, St George Ltd, Borders Books and the Royal Borough of Kingston upon Thames, it was unveiled on 7 November 2003 to commemorate Queen Elizabeth II's Golden Jubilee and visit to the town in 2002.

The artist, John Richards, who had previously illustrated the 'Town of Kings – March Through Time' poster for the Millennium, prepared the drawings, scanned them and Burnham Signs of Sydenham transferred them to four steel panels and fired them in a kiln. John then added colour by hand and they were fired again to give a durable and weather-resistant finish which is as fresh today as when erected.

Guildhall Entrance

Standing by the steps to the Guildhall you can see various sculptures which, hopefully, will distract you from contemplating why a monstrosity of a tower, with colonnaded portico, was built on the front of an otherwise proportioned 1934/5 semicircular building.

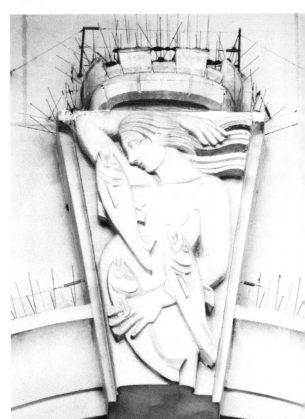

A depiction of Kingston upon Thames. Not credited, but perhaps 'after Gill'?

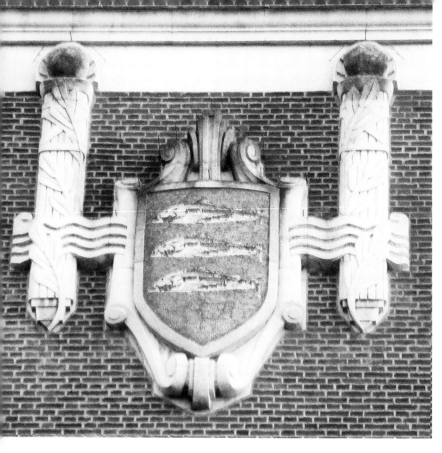

Why are there leaves on the Fasces? Not credited but, again, perhaps 'after Gill'?

The golden figures of Hope and Plenty and the three salmon above the door were sculpted by father and son Walter and Donald Gilbert, who also worked with architects Sir Aston Webb on the sculptures for the gates of Buckingham Palace. Each side of the door is an artistic depiction of a produce-laden barge being drawn by a pair of barge horses and above, in relief, is a fasces lictorae, attributed to Walter Gilbert, signifying the convening of the old Magistrates' Court at the Guildhall.

Above the window beneath the pediment is a sculpted depiction of the town, with a nude female whose flowing hair represents the Thames and three salmon representing Kingston. The work appears (to me) to be in the style of Eric Gill, who at the time of construction was working on the Bentall's corner extension for Aston Webb Architects.

On the face of the brick tower there is a more traditional Kingston crest of three salmon, each side of which is a vertical column that also appears to be a bundle of canes, similar to a fasces lictorae. Each bundle is adorned with wide leaves, again in the style of Eric Gill. Neither work appears to have been attributed to him or his studio but the similarities are there.

Atop the tower is a wind vane depicting a barge, the bargee and his dog.

H

Hawker 'Hurricane'

In October 1935, the front doors of a nondescript building in Canbury Park Road opened. To the metallic sound of a chain and winch, a design that would change the world was lowered onto a flatbed lorry that had reversed into the doorway. The winch, chain and hook are still there to this day.

Scrutinising the action was the designer Sydney Camm, whose design fulfilled an order for a high-speed monoplane – a single-seater interceptor fighter. The parts were conveyed to Brooklands Airfield where they were assembled as a large model kit. On 6 November it took off, flew circuits, passed other tests and landed.

The structure comprised the Camm/Sigrist cheap and simple design of a tubular metal skeleton covered with a doped fabric skin which could sustain greater damage than the Spitfire and was easier to repair and return to combat. Pilots agreed that the fighter was more accurate and stable when firing than the Spitfire.

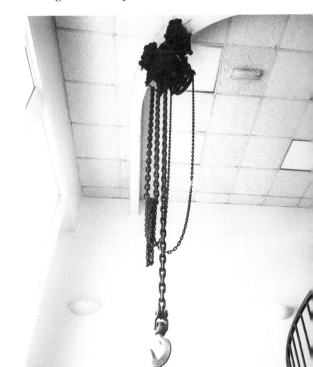

The hook, chain and pulley at the front of Siddeley House that hoisted and then lowered the prototype Hawker Hurricane onto a lorry bound for Brooklands. The rest is...

Camm named it 'Hurricane' – understandable as, being the first operational RAF aircraft capable of exceeding 300 mph, it was faster than his earlier 'Fury' from which it had evolved. His subsequent designs, 'Typhoon' and 'Tempest', would follow this theme.

Squadron No. 111, at Northolt, received the first Hurricanes before Christmas 1937. The squadron's CO flew one from Edinburgh to Northolt, averaging a ground speed of 408 mph. It could climb to attack high-flying enemy reconnaissance planes and had a small turning radius, essential in a dogfight.

One thousand seven hundred and fifteen Hurricanes flew during the Battle of Britain, exceeding all other British fighters combined. It is said that Hurricane pilots were credited with 80 per cent of all enemy aircraft destroyed between July and October 1940.

Despite Camm's technical brilliance, luck played her part. In 1936, Hawker's chief production engineer, Frank Murdoch, visited Germany to oversee testing of diesel engines for Sopwith. Astute enough to notice, he realised the potential implications of the vast numbers of U-boat engines, fighter planes and bombers in German production. On his return, Hawker immediately changed their production line, commencing Hurricane production ahead of any official order. When the Air Ministry, fearing war, eventually needed Hurricanes, they were already in production.

What if Sopwith hadn't sent Murdoch to Germany...?

Henry Bottom

Spare a thought for poor Henry. In 1646, with increasing frequency, the burial register lists the cause of people's deaths as plague, plague, plague, and then on the 13 April is Henry's entry and cause of death: smallpox! The registers then return to plague. He is the only person for years who is registered as dying from smallpox. However, 370 years later he is hereby remembered. His somewhat unfortunate surname made me reach for Shakespeare to recall the fate of his namesake, the butt of the play's humour, who puts it all behind him in the end.

Highwaymen

I doubt that you will know of John Lonn, highwayman, buried in Kingston on 19 August 1721, or William Gibson and his 'private cave', in Coombe Wood, in which he concealed himself during the day, venturing out to rob at night. He was apprehended by gentlemen shooting in the wood and executed at Kennington Common in August 1755. These were petty criminals, lacking the flair or notoriety to become known throughout the land.

However, in a relatively short life, Lewis Jeremiah Haversham, born in Kingston *c.* 1773, made quite an impact under his alias Jerry Abershaw, 'The Laughing Highwayman'.

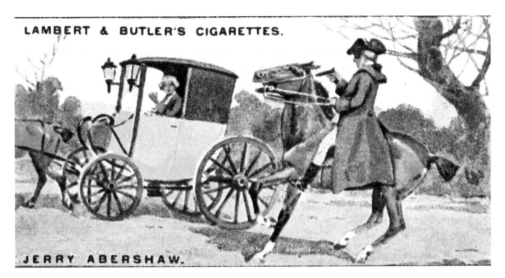

LAMBERT & BUTLER'S CIGARETTES.

JERRY ABERSHAW.

Abershaw as depicted by popular culture.

Dickens has Nicholas Nickleby refer to him and Robert Louis Stevenson, in 1881, believing that he will have a bestseller, writes that 'Jerry Abershaw' are 'The two most lovely words in English'. He was even compared, in ironic humour, with one of Britain's greatest statesmen, William Pitt (The Younger). Wags would comment that 'whereas Jerry Abershaw takes purses with his pistols, Pitt takes them with his Parliaments, the one instrument being not much better than the other'. Prolific playwright George Dibdin Pitt immortalised Abershaw in one of his 250 melodramas.

Starting as a driver of a post-chaise, Abershaw quickly determined that encouraging passengers to relinquish their valuables was far more profitable. The nature of his 'trade' meant that it was hazardous to remain in one area. Although regularly operating over Putney Heath and Kingston Hill, with Coombe Wood, like Gibson, being a favourite haunt and having boltholes at The Green Man Inn (Putney Hill) and the Bald-Faced Stag Inn (Kingston Bottom), he roamed as far as Chelmsford where, in 1792, he was caught and tried for highway robbery. His luck held and he was acquitted.

He often recounted with humour how, one dark night, he was taken ill on Putney Heath and brought back to the Bald-Faced Stag. A doctor from Kingston bled him and was about to return home when Abershaw, expressing concern, said 'You had better, Sir, have someone to go back with you, as it is a very dark and lonesome journey.' The Doctor declined, stating that he 'had not the least fear, even should he meet with Abershawe himself'.

A police notice dated 15 January 1795, issued three days after two constables were shot at trying to apprehend him, described him as 5 feet 6 inches, of fair complexion with dark grey eyes, brown curling hair, sometimes worn loose, sometimes tied, of genteel appearance and often wearing boots. Officer David Price was killed and the second, Barnaby Windsor, was dangerously wounded. The notice offered 'the King's

Abershaw as he was.

most gracious pardon to anyone who discovers the person who committed the murder of Price'. As an added incentive the notice included a reward of £100 (£7,700).

Abershaw was eventually captured and brought to trial at Croydon on 30 July, charged on two indictments. On his way to trial he passed the gallows at Kennington Common and, leaning out of the coach, asked his guards if they thought he would be 'twisted' there by Saturday.

The jury took only three minutes to pronounce his guilt, which was followed by two hours of legal debate as his defence barrister, Mr Knowles, argued a flaw in the indictment. The judge decided that this had to be put to the twelve Judges of England. It appeared, momentarily, that Abershaw would return to prison but William Garrow, arguably the leading barrister of the time, insisted that Abershaw be tried for the second indictment there and then. Abershaw was again found guilty and sentenced.

When the judge had the black cloth placed over his head to pronounce sentence of death, Abershaw donned his own hat, scowled and cursed the judge and jury that he was being murdered on the testimony of just one witness.

Awaiting execution, he amused himself by using black cherries to paint images of his exploits on the cell walls. In one, he presented a pistol to a post-chaise driver with the words 'Damn your eyes, Stop' emanating from his mouth. Another showed him firing into a coach and a third showed people firing back and a companion being shot dead.

Around 10.00 a.m. on Monday 3 August, Abershaw and two others, James Little and Sarah King, left the gaol and were taken by cart to Kennington Common. Abershaw

appeared unconcerned, shirt open, a flower in his mouth; he laughed and kept incessant conversation with acquaintances he noticed in the immense crowd that had gathered along the route.

When the cart stopped beneath the gallows he threw away his handkerchief and hat, saying he had no further use for them. He also threw away a prayer book offered to him and kicked off his boots saying that, by doing so, he would prove his mother wrong as she had often said he'd die with his boots on.

He shouted a dreadful curse to his prosecutors and without waiting for the cart to be pulled away he exclaimed 'Here goes it!' and launched himself into eternity.

His body was hung in chains on Putney Heath and, as of 1800, his remains were still there. A small mound opposite the junction with Roehampton Lane still bears the name 'Jerry's Mound'.

Humiliation Ann Wortley

Puritans were, it seems, not averse to giving unconventional names, many of which have survived to this day, for example Felicity, Hope, Trinity, Verity and Prudence. But others such as 'Die-Well', 'Farewell', 'Kill-sin', 'Praise-god' and 'Fear-god' have fallen by the wayside, as has 'Humiliation'.

If a Puritan father died before his baby's birth, the child was often named 'Posthumous'. In Kingston's baptismal registers there is an 'Ann Posthumous Crew', 17 November 1761, and a 'Posthumous Waklin', 31 January 1686, whose father had died and been buried on 28 July 1686. Yes, the dates are correct; his father had died in July of the same year which preceded January. Up until 1752, and Britain's change to the Gregorian calendar, the Julian calendar ran from 25 March (New Year's Day) to 24 March (New Year's Eve) such that 24 March 1686 was 365 days after 25 March 1686 – confused?

As for Humiliation Ann, she was born in Kingston and baptised at All Saints' Church on 2 March 1770 and took her mother's name. There is no further record of the family staying in Kingston. Not surprising considering that, for her father William, it was just one Humiliation after another.

Recently, the naming of children was in the press following airline staff having ridiculed a five-year-old American girl's name, 'Abcde'(pronounced 'Ab-se-dee'). Perhaps the days of naming children after sins are not gone but are evolving and, one day, an over-sized family may even name their child 'Obct'.

Icarus

'Although history has long forgotten them, Lambini and Sons are generally credited with the Sistine Chapel floor.' So reads the caption beneath a 1991 Gary Larsson cartoon that I think of each time I pass the 1987 bronze sculpture *Icarus* by Carole Hodgson. Inexplicably, this is located, and oft ignored, at the foot of the stairs of the Cattle Market car park, unseen by those paying for parking. Ironically, it is to the side of the cow mosaic by 'telephone boxes' artist David Mach, which I suppose Larsson and his 'cartoon cows' would appreciate.

If there is one sculpture that captures the essence of Kingston for me, Hodgson's bronze is sky high above all others. Telephone boxes may be iconic but they say nothing about the town. For me, the character of Icarus represents early flight and the astronaut, 'the future'. Between them the bridge and the leaping salmon tell of the river and trade, of people coming to Kingston. Icarus confidently holds or launches the Sopwith Camel reassured in its success and ability to conquer flight but, with the Hurricane, reassuring us of the protection it provided in our darkest hour.

The artwork exudes designs that have come from Kingston and considering that Hodgson was, at the time, a tutor at the sculpture department of Kingston Polytechnic, located where world history changed – Canbury Park – the work speaks of the future designs. It celebrates and commemorates the town's long association with the aeronautical industry and was presented to the town by British Aerospace. Knifton tells us that the astronaut was a last-minute addition paying tribute to

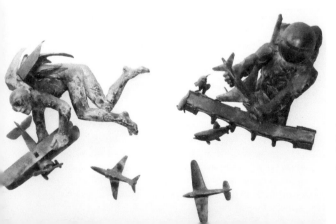

A travesty! Why is this fine sculpture of Kingston and its aviation heritage 'hidden' in the Cattle Market car park?

Chief Test Pilot Jim Hawkins at BAe Dunsfold, who had died demonstrating the Hawk 200 prototype in July 1986. Surely this work deserves to be relocated to a position of pride!?

Is it a K or an R?

No one knows for certain which letter sits beneath the three salmon on Kingston's town seal. It is variously described as being an 'R' for Regis ('of the King') or as a 'K' (for Kingston).

The right to use a common seal to 'serve for things and business' was granted by Henry VI's 1441 charter and comprises a shield with three salmon swimming to the left, the letter beneath. The right was later confirmed by Charles I, whose 1629 charter granted that it shall be lawful for the bailiffs and freemen of the town to break, change and 'new-make' the common seal as they see fit. This privilege was exercised and a second seal was prepared comprising a 'K' above a beer barrel, or 'tun', flanked by oak leaves. This punning rebus forms 'King's tun' which can be seen at the base of cast-iron railings (on the Hampton Wick approach to the bridge), on the decorated façade in the Market Place and as an illuminated light in the Wood Street entrance to the Bentall Centre.

Correctly used as the 'Seal of the Court of Record', it has been erroneously referred to as 'the Seal of the Town', whereas it is the earlier seal, with the three salmon, that is recognised as the 'Common Seal of Kingston-upon-Thames'.

The seal, with the letter, can easily be confused with the heraldic 'Arms of the Town', the difference being that a seal has no colouration, solely leaving an indentation (later an ink imprint) whereas the arms display heraldic colour. A coloured shield and

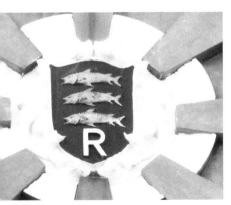

Above: High in the corner of the Market Place are three salmon, noticeably lacking red-coloured fins and tails, with an 'R'– rightly or wrongly.

Right: Town seals in the museum. (Photo courtesy of Kingston Museum)

salmon with a letter beneath, as on the terracotta stone-faced store in the corner of the Market Place (which was once Nuthalls' Restaurant, the Edwardian 'place to be seen and dine'), is a composite of the arms and the seal.

The arms of Kingston-upon-Thames were granted on 10 September 1572 and, in heraldic terminology, comprise 'Azure, three salmon naiant in pale argent, finned gules', or blue background, three silver salmon with red fins, swimming.

In the Domesday Book, 'Chingestune' (Kingston) is recorded as having two pilcarie (fisheries) rendering a rent of 10s, and a pilcaria (fishery), very good but without rent. The three fish on the arms recall this entry and, as for the salmon, Biden writes that 'the Salmon was formerly caught here in considerable numbers: and it is mentioned as an article of trade many years before Henry VI granted the town a Charter of Incorporation'.

In 1965, the two former boroughs of Surbiton and Maldens and Coombe were absorbed into the Royal Borough and the coat of arms of the larger Royal Borough of Kingston upon Thames (no hyphens post-1965) now incorporates a crest derived from the Maldens and Coombe and two flanking stags holding the arms of Surbiton.

IYAF

The International Youth Arts Festival was launched in 2008 and for ten days or so each July, it highlights the very best of youth arts theatre – music, dance, film, comedy, circus, cabaret, visual arts, workshops and installations – from all over the world and, in so doing, has inspired others. It provides a stage for professional companies or artists to test something new, or simply for performers wanting an opportunity to show what they can do to the appreciative, supportive and undoubtedly welcoming audience that Kingston provides.

Now considered a precursor to the Edinburgh Fringe and the UK's biggest multi-arts festival for performers under the age of twenty-seven, it celebrates the global talent of young people in the arts. The festival includes over 200 events at venues across Kingston including the Rose Theatre, the Arthur Cotterell Theatre and an outdoor stage with live music at the historic Market Place.

Strange how some of us never visit what is local or see what is right in front of us. However, watch the influx of smiling faces and feel the excitement in early July and you will know that it's IYAF time and it's on your doorstep.

Just go! You'll have fun!

J

Jerome K Jerome

Jerome knew Kingston. He regularly journeyed to Richmond by train on a Sunday morning with friends Carl and George, and they would find their way to Staines by river, stopping off along the way.

On return to his home in Chelsea Gardens, having honeymooned on the Thames, he penned his novel *Three Men in a Boat*, about three friends travelling upriver from Kingston. He, anecdotally, tells of a great carved oak staircase, in a shop, where a

Eden Street mural depiction of 'Three men in a boat (to say nothing of the dog)'. Montmorency (the dog) is not shown – perhaps he is hiding in the boat?

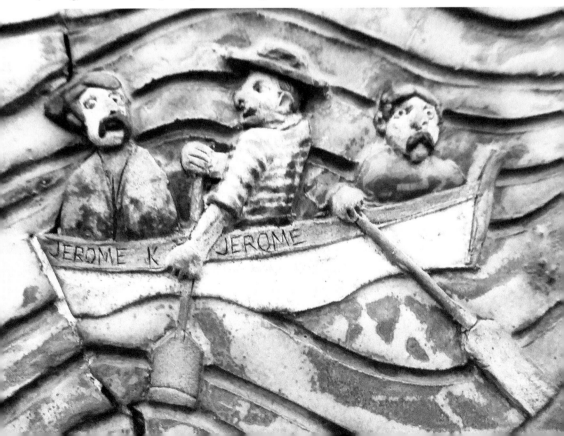

The verse scratched on the cupboard glass, attributed to Jerome. (Photo courtesy of The Druid's Head)

friend who lives in Kingston once purchased a hat and, 'in a thoughtless moment, put his hand in his pocket and paid for it then and there!' This undoubtedly refers to the carved Jacobean staircase in the shop, currently 'Next', just along from the Druid's Head, an old coaching inn where Jerome is believed to have stayed. There he reputedly inscribed a poem on a glass pane of a cabinet in the front drawing room.

The hand-written inscription is still there, comprising four lines, but Jerome was not the poet. Three of the four lines are from the last verse of William Shenstone's early eighteenth-century poem 'Written at an Inn at Henley', the second line having been subtly changed. Curiously, an 1881 guide to the river, 'Our River' by George Leslie, which the descriptions in 'Three Men' closely resembles, contains the complete poem, stating that it was once inscribed on a glass pane at the Red Lion Inn at Henley, but is now lost. It seems likely that Jerome had a copy of 'Our River' and repeated Shenstone's act of graffiti in Kingston.

John Who?

Many surnames originated from occupations or descriptions. Differentiators in medieval records provide an insight to how people with the same given name were recognised.

Between 1235 and 1376, three Kingston 'Johns' were separately fined for selling ale in Bishops' Hall at above the prescribed cost. We can tell who John le Brewer was but what of John Le Malemayns and John le Woghere?

David Stone, in translating the Esher Manor accounts, attributes 'Dirty Hands' and 'Wooer' to these transgressors, the latter deriving from Old English, Wogere (to woo or court). The former could also be, conceivably, 'bad hands' as opposed to dirty. One wonders what they did to be given such names.

Kingston Art

Where to begin? This subject is a book in itself. Forgive me then if I adopt a 'less is more' stance. I desperately want to tell you about the Carnegie Art Gallery, Public Art, Kingston School of Art, the Brill Collection, School Art projects and the Stanley Picker Gallery but fear I will do none of them justice in a few words.

If you are fortunate enough to live, work, visit or have access to Kingston, have the slightest interest in art and know nothing about the foregoing then all I can say is that you are about to have the most fun ever!

Kingston has never seemed to sell itself as a cultural centre, perhaps relying too heavily on its ancient heritage, which gets tweaked and subtly disappears due to

Public art is everywhere in Kingston.

cutbacks here and development incentives there. But alongside its ancient historical heritage there is a solid foundation of art culture; you just have to look around. Visit the Stanley Picker Art gallery. Check to see what is displayed above the museum.

Schools display the works of talented Kingston students, the university's art department is renowned, galleries are regularly displaying works and public art is wherever you go.

As for our art heritage, Reginald Brill, Head of Kingston School of Art in 1934, left us a legacy in the Brill Collection he inspired, which is held at the Art Gallery/Museum.

Kingston and History

English and world history have each been affected directly by Kingston. Twice Kingston Bridge has, crucially, either prevented or delayed rebellious crossings which, had they succeeded, would have changed the course of the English monarchy.

The unsuccessful crossing of 20,000 Lancastrian supporters here in 1471 secured Yorkist Edward IV's position as king and saw the subsequent murder of Henry VI. Had the crossing succeeded and Henry VI been released, it is unlikely that the York line would have continued. Richard III would not have succeeded Edward's son as king. The Battle of Bosworth would not have happened, Henry VII would not have been victorious and so there would have been no Tudors, Stuarts, Georgians and Victorians.

What happened here at Kingston Bridge affected English history in both 1471 and 1544.

What happened here in Canbury Park Road affected world history in both 1914 and 1939.

Wyatt's delayed crossing here in 1554 led directly to the execution of Queen Jane. Success and release of Jane could have seen her rightfully restored to the throne, ahead of Elizabeth with the same effect to the monarchy, i.e. no Elizabeth, no Stuarts, Georgians, etc.

Separately, consider Cellon, Sopwith Aviation and Hawker Engineering. Without Cellon's dope, Sopwith and, later, Hawker, planes would not have been airworthy; without test pilot Harry Hawker and Sopwith Britain's aerial reconnaissance and fighter presence in the First World War would have been secondary to that of Germany, leading to the likelihood of defeat prior to the USA joining the war.

Without Sydney Camm and Frank Sigrist coming together at Hawker Engineering in Canbury Park Road there would have been no Hurricane and the Battle of Britain would have been lost and with it the last stronghold of freedom in Western Europe would have succumbed to invasion.

The Kyngham

We know what it was called, when it was performed ('Kyngham Day') and how much it cost, but we have little idea about what it entailed as no description has survived.

Lysons considered it 'an annual game, or sport, conducted by the parish officers, who paid the expenses attending it and accounted for the receipts'. He

continues that 'the clear profits, 15 Henry VIII amounted to 9l 10s 6d (£5,000) a very considerable sum'. Including monies 'paid out', the Kyngham raised approximately £8,000 today.

In the 1506 accounts the 'Kenggam' featured William Kempe as King and Joan Whytebrede as Queen, providing a link with Whitsuntide 'King's Revels' held elsewhere when a King and Queen of the Summer Games were chosen. It was the appointed King's duty to hand all receipts from the games to the churchwardens for the relief of the poor.

Accounts for St Lawrence, Reading, refer to receipts from the 'Kyng game' (1541) and, in 1557, gathering at the 'Kingale' at Whitsuntide. A Kingston entry for 1504, 'at the geveng out of the Kynggam by Harry Bower and Harry Nycol ... of that same game', suggests that the Kyngham may have been the name for specific donations to the poor of the parish from the proceeds.

Spelling was fluid and Kyngham was sometimes used for 'kingdom'. The Kyngham may then have been less of a specific, repeated play and more of a grand parish feast, on 'Kingdom day' or a Kingdom presided over by the chosen king and queen. Games and merriment were accompanied by drummers and lute players with ale, bread, mutton, veal, pork and goose sold for the benefit of the church fund. It could simply have been akin to an annual church fete and barbeque but on a much larger scale, attended by the entire town.

Below left: The King of May. (Photo courtesy of Kingston Museum)

Below right: The Queen of May. (Photo courtesy of Kingston Museum)

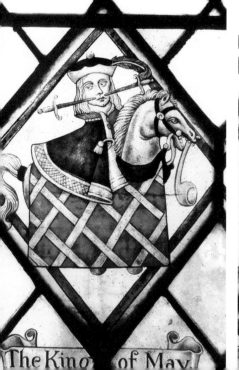 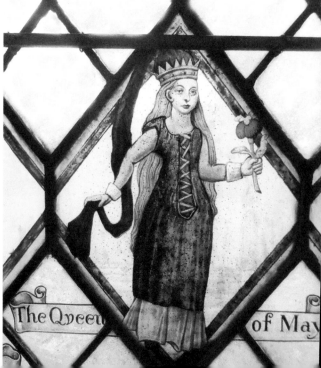

L

Longevity

We believe that longevity is a modern phenomenon arising from improved standards of living and medicine. There are, however, people recorded in the burial registers as having lived to an old age.

We have to view stated ages with reservation as only after introduction of civil registration of births, marriages and deaths in 1837 could calculation of age be considered accurate. However, as Henry VIII's 'Vicar General', Thomas Cromwell ordered clergy (1538) to keep records of all baptisms, marriages and burials and as clergy could perform basic subtraction, the ages recorded should not be considered as 'fanciful', although errors undoubtedly occurred.

William Franks, ninety-nine in 1758, just misses out on joining the registered Kingston's centenarians. Widow Preston, from the Almshouses, was 100 (1696) and Mary Wilkinson, 102 (1721).

But these are youngsters compared with Winifred Woodffall who died in 1690 aged 108 and, finally, Florence Phillips, registered as 110 years when buried on 26 February 1677.

Lovekyn Chapel

Lovekyn Chapel, the last free-standing chantry chapel in the country, owes its existence to a lavish wedding feast of September 1299 which Edward Lovekyn (of Kingston) prepared for the marriage of King Edward I to Margaret of France.

Celebrations lasted four days and cost Lovekyn 1,000 marcs (£475,000). He sought to reclaim this from the King, who arranged to honour his debt, but revenue was to be from land he had allocated to his new queen, who would not relinquish income to pay the monies due.

Seven years of war with Scotland and France followed, laying further waste to the king's finances and, as he increased taxation, internal resentment heightened the threat of civil war. Lovekyn received part payment but requests for full settlement would have been a low priority for the king and when he died (1307) payment remained outstanding.

Lovekyn petitioned Edward II and brokered a deal. He would write off the debt if he could assign land for a private chantry chapel 'to celebrate the souls of the Lovekyn

family and all faithful departed now and in the future'. The king granted the petition in 1309 and, obtaining permission from the Bishop of Winchester for a chaplaincy, Lovekyn had his chapel.

Over the next 200 years chapel ownership changed but it remained privately owned and should not have been subject to dissolution when Thomas Cromwell turned his attention to the wealth of ecclesiastical properties. However, by an audacious Act of Parliament, Henry VIII legally carried out daylight robbery whereby he appropriated private property 'in consideration of the great cost in the protection of the Kingdom and for the maintenance of his honour and dignity'.

The legal uncertainty of Henry's 'ownership' is prominent in Elizabeth's charters of 1561 and 1564, gifting the chapel and monies for the creation of the grammar school. She handed over to the school governors 'the rights, fully and entirely, of all and any who previously possessed as the same had come into her hands or those of her father and brother by any Act of Parliament, or any other right or title'. Simply put, she is saying 'I don't know how we have acquired this but none now have claim as I, Elizabeth, give all rights to the governors.' So much for the souls of 'all faithful departed now and in the future'.

Lovekyn Chantry Chapel which, perhaps, previously heard the daily prayers of lepers.

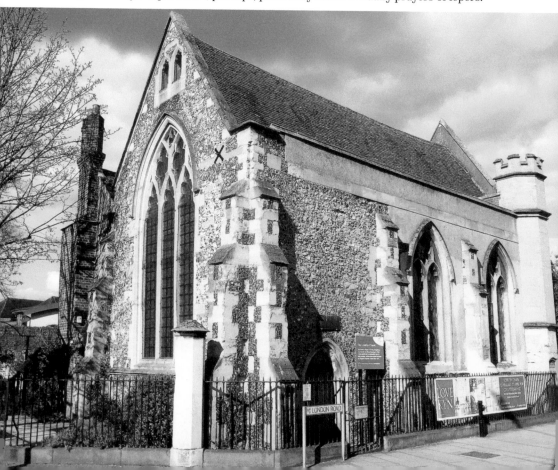

M

St Mary Magdalene's Chapel

Where was the Lepers' Hospital? No one knows. They were often sited just outside the town on a main thoroughfare and frequently had an adjoining chapel. References simply state that 'about 1316' the inmates quitted it, pulled down the building and carried away materials, with the land seized by the Crown. But what if they left, say, ten years earlier and the building wasn't razed to the ground? What if they just left the chapel in disrepair?

As Edward II, approached by Edward Lovekyn, a Kingston resident, willing to broker a deal to settle a debt, all you need to do is make some land available for construction of a chapel. Would you offer valuable land or the site of a recently vacated lepers' hospital, with an existing chapel?

The wording of Lovekyn's licence is interesting as he specifically refers to 'the chapel of St Mary Magdalene, Kyngeston', which clearly implies that the chapel was already in existence. There is no question of Lovekyn deciding to whom the chapel will be dedicated. It's a case of the king permitting use of an existing chapel dedicated to St Mary. This explains the apparent contradiction where the patent implies the chapel as existing but the Bishop of Winchester, six months later, refers to it as 'lately erected'.

I believe Lovekyn took over the chapel of the leper's hospital and renovated it as, had he built a new chapel, it seems unlikely that it would have needed to be 'newly constructed' by his son forty years later.

It's only conjecture that the chapel was the original site for the leper hospital, but then, across England, there are a number of contemporary leper hospital chapels and, coincidentally or significantly, these are dedicated to ... St Mary Magdalene.

Mary Morton

Most people ignore the scratched, illegible, blue-black marble floor memorial stone in the chancel of All Saints' Church. There is nothing to read and so it is of no interest. Even the coat of arms has worn away. The inscription was fortunately recorded by John Aubrey between 1673 and 1692 and the gravestone recalls Mary Morton (née Honywood) buried in 1634 but, more importantly, it tells of her mother.

Beneath this now illegible stone 'rests' Mary Morton, one of the 367.

'Sacred to the memory of Mrs Mary Morton, daughter of Robert Honywood of Charinge, in Kent, Esq; (by his wife, the Wonder of her Sex, and this Age, for she liv'd to see near 400 issued from her Loynes)...'

Robert's wife, also Mary, gave birth to sixteen living children of which Mary was one. They raised 114 grandchildren and, in turn, 228 great-grandchildren. By the time of her death in 1620, at the grand old age of ninety-three, Mary had nine great-great-grandchildren. In all, she saw 367 descendants.

Memorials

It is no coincidence that a child is depicted on each of the town's two prominent memorial statues: the Shrubsole memorial and the war memorial. The symbolism portrayed is that the future will be protected.

The Shrubsole memorial commemorates Henry Shrubsole, three times mayor who died in office in 1880 while distributing packets of tea to the elderly at a charity function. The memorial was funded by public donation, which raised £500. Francis Williamson, Queen Victoria's favourite sculptor, chipped away at the 8-foot-high slab of marble in his studio home at No. 79 Esher High Street.

Designed to be practical, consensus settled on a drinking fountain at a time when few houses were supplied with fresh water. Williamson's original marble base was changed to granite, this being more suited for fountain use. The increased cost of granite meant that the quality of the marble for the statue had to be reduced. It depicts a female figure

Above left: When you next pass this statue, look at the security of the hand-holding.

Above right: The boy looks up in the knowledge that his future is safe.

holding a vase, and the left hand of a young boy, who is crouching to collect water in a small bowl, implies that water will be freely available for the future generations.

Two children are being protected on the bronze war memorial by Richard Goulden, a prolific sculptor of war memorials and credited with eleven, from Dover to Great Malvern to Gateshead. The statue depicts a man, the spirit of youth, defiantly holding aloft the flaming torch of self-sacrifice whilst impaling with his sword the evils on life's path, represented by a serpent.

Kingston Council had specifically ruled out any form of military imagery for the memorial and Goulden's sculpture successfully provides dignity, optimism and hope.

Milestone

Milestones are like mini time machines and always make me think of who once stood there and when.

On a low wall in Surbiton Road, at the junction with the Portsmouth Road, is an old milestone. Sadly, it has been partially and irreparably damaged and, until recently,

When did you last stop to really look at and think about a milestone?

all meaning had been lost. But interest and dedicated research has decoded the inscription. A YouTube video entitled 'The Mystery of the Milestone' tells the story and a small plaque replica positioned alongside reveals that the original once advised travellers that it was 'IIII Miles 3 Quarters 1 Furlong 28 Rod from Ewell Market Place'.

In 1628, believing its markets were being threatened by the establishment of other markets in local towns, Kingston successfully petitioned Charles I, who issued a charter stating '...no other market shall from henceforth in future be created anew, or in any manner appointed, or in any way held in any place whatsoever within the distance of seven miles from the aforesaid town of Kingston upon Thames...' This exclusion zone remains in force to this day.

Ewell Market was actually established in 1618, but its proximity demonstrates the fear that Kingston had of losing its market trade to nearby towns.

Model Planes

Thomas Wigston Kinglake Clarke of Marshfield, Gloucestershire, was a civil engineer who relocated to St Andrews Square, Surbiton. Seriously wounded in the Boer War, he returned and, in 1903, became Britain's first aeronautical consulting engineer, living with his sister at No. 52 Maple Road, Surbiton.

Clarke established a company manufacturing model aeroplanes. Initially working with gliders, he covered his models with a cellulose fluid, thus pioneering 'doping'. He patented the 'Clarke Flyer', which went on sale in March 1907 and thousands were sold before other manufacturers could compete.

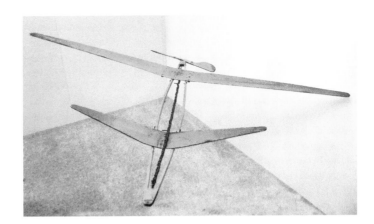

Clarke Flyer. (Photo courtesy of the Science Museum)

The Clarke-Wright Glider.

Clarke's models were loved by all and every part was standardised so it was easy to obtain replacements. Open, assemble, connect the rubber band, wind the 8-inch propeller and after running across the ground the 'Flyer' would take off by itself and fly for 150 yards. His Sopwith biplane model closely followed the lines of the full-sized plane and had a span of 25 inches, was 30 inches long and had a 9-inch propeller.

Among other models available from the Kingston works was a loop-the-loop monoplane, which could be adjusted to carry out realistic 'stunts'. He also marketed a waterplane with three floats that would take off from a pond and fly for 250 yds.

Clarke progressed to full size, having agreed terms with the Wright brothers to develop their biplane glider and the Clarke-Wright Flyer, built at No. 22 High Street (today the Rose Theatre), made record glides. He improved the Wright brothers' design by covering the wings with two layers of doped material instead of the brothers' patented single layer. The manned glider was marketed as a means of learning the basics of flying before taking to the sky with a powered machine.

Modifying controls, the pilot sat in a chair with levers each side, as opposed to the Wright brothers' design of the pilot lying prone. An original, restored, 1912 Clarke-Wright Glider from Kingston currently hangs in the RAF Museum at Hendon.

Intriguing to think that Sydney Camm, a keen aircraft modeller and a teenager in Clarke's commercial heyday, could well have flown Clarke's models long before he became designer at Hawker Engineering and considered the modular framework for his aircraft.

Netta

Only one lady is listed on the Kingston war memorial: Ellen (Anetta) Broad, who was a member of the Women's Royal Air Force, stationed at No. 1 M.T. Repair Depot, Hurst Park. She was a war casualty because she died of septic poisoning arising from an injury she received whilst working in the Vulcanising Department, where extensive use of solvents and other chemicals could cause chronic poisoning. Dope was equally as deadly.

Netta attended Richmond Road Council School and was employed as a domestic nursemaid prior to enlisting in August 1918. She is buried in a war grave at Bonner Hill Cemetery.

The war memorials Band of Brothers – and one named Sister.

Noah's Ark

Hugh Kermock, known in early nineteenth century as either Dr Cormac or simply 'old pills and powders', lived in an ivy-covered cottage set back from Norbiton Street (Clarence Street) where today there is a junction with Fife Road. Over his door a sign advertised his profession as 'Surgeon and Accoucheur', the latter being the male equivalent of a midwife.

Ayliffe describes him as 'a little man with spectacles, black knee breeches and silk stockings, a tassel in his hat, and an umbrella loosely tied of ancient type, the colour of the cover being green with a border. He lived on to a great age'. He is recorded in the 1851 census as being eighty-seven and born in Scotland.

At the rear of his house was a great barn with a large roof under which Kermock had erected a number of wooden huts as tenements, each with either two or three rooms, separated down the middle by a common passage with a single water pump. The size and shape of the barn led to it being called 'Noah's Ark'.

Kermock leased the rooms to people who Merryweather calls 'the most disreputable among the poor'. The census reveals that there was a tailor, a weaver, an auctioneer's porter, a light porter, a couple of labourers and one 'Caroline Harms' who, as a 'Repairer of Umbrellas', may well have been the cause of the doctor retaining his ancient brolly.

Odours

It is easy to view the town as always having been an airy market town, positioned alongside the fresh, windswept River Thames. Odours today are encountered locally and not a single foul odour pervades the whole town. However, it is only since the Winery closed in the 1980s that this has been the case. Until then distinctive smells from local industries would blow through the town into shops and houses alike.

The site of the ovens of the Native Guano Company works and later Kingston's power station.

The road south towards Surbiton was the source of three such odours. Malthouses lined the road. Wetted barley warmed by coke created a sickly sweet, malty smell, which mixed with the pungent brewing odour from Fricker's Brewery at Eagle Wharf and the essence of Nightingale's gin distillery, located where the police station is today.

A different perfume came from the east – and it wasn't frankincense or myrrh. The smell was of linseed oil from Oil Mill Lane, now Villiers Road. When oil production ceased, the mill produced candles and soap. Closure of these factories changed the smell and the wind delivered 'essence of the VP Winery' and the refuse centre.

On entering the town these met the brewing smell of Rowell's brewery (later Hodgson's then Courage and Co.) in Eden Street. For a comparatively short time the north wind provided the smell of ginger beer from R. White's bottling plant just west of Dolphin Street, where Bentall's is today.

These peripheral wind-blown industrial scents may have been considered pleasant in comparison with three other foul odours in the town. From west of the Market Place came the stench from vats of boiling animal fat in Ranyard's tallow chandlery. Just west of Seven Kings' car park was the Native Guano Co.'s factory where open settling tanks separated human fluid from solid human waste. The fluid was discharged back into the Thames but the sludge was collected, baked in large ovens and, when cool, placed in bags as fertiliser and exported worldwide. To cool, the oven doors had to open and the warm smell of cooked human waste spread outward and across the town. The factory closed in 1909.

The foulest smell entering the nostrils in living memory has to be that emanating from the Tannery, located between Thames Street (once called the Bond Street of Surrey) and the river. It was operational between 1674 and 1963. To separate the fats and hair from the hides to create leather, skins were soaked in open tanks of urine and dog excrement collected locally.

Kingston has never smelled sweeter than it does today.

Old Chitty

Few know of Old Chitty but in 1670 he was paid 13s 4d (£80) per annum for carrying out an important community service. He was 'the whipper', tasked to carry out sentence on those whose offence was not of a 'capital' nature as well as ensuring dogs stayed away from the church and fish market.

Churchwarden's records advise that, in 1634, they paid 18d (£10) for 'a new vizard and cap for the whipper'. Twenty-five years earlier they had paid 3s (£20) for 'a coat for the whipper', perhaps to keep his muscles warm.

It appears that, for a time, Old Chitty was both whipper and crier. Did he, I wonder, announce the punishment and then don his vizard and cap to oversee the execution?

Organ Grinding

In an effort to clear up the abysmal conditions of the slums that were the 'Back Lanes', where John Lewis, the underpass and Bentall's car park are today, families had to relocate. But different did not mean better and in 1901 the 'Italian Quarter' was forced to take residence where they could. Unfortunately, this placed them in worse conditions – the slum cottages of Fairfield Place off Mill Street, close to the rat- and insect-infested Hogsmill River. Their chance of improvement was limited by profession and employment. The occupation of most, stated in the census, was 'organ grinder', though some tried to make themselves feel better by stating 'musician', only to have the enumerator write organ grinder alongside.

Typically the organ, supported by a wooden stick, would be steadied by a neck strap with one hand levelling the organ, leaving one hand free to turn the crank. A tin cup in the hand of a companion, often a monkey, was used to promote payment.

It was not street music but 'begging by notes'. They were everywhere and Dickens once complained that he could not write for longer than half an hour before being interrupted by the sound.

Christopher French, in a highly recommended study, has investigated the social conditions in this community, highlighting their plight with 60 per cent of deaths over forty years from the one small street being that of children before the age of five. Monkeys, rats, insects and young children didn't mix. The monkey was an earning 'performer', the child was not!

Living close and crowded with infestation can take its toll. Fairfield Place neighbours Angelo Valenti and Stephano Marsella quarrelled and Marsella struck Valenti with a broom handle. Arrested for murder, he pleaded guilty to manslaughter and was sentenced to eighteen months' hard labour. The coroner was openly damning of the slum landlords who took money for providing squalid conditions. This had no effect and George Street, the landlord, later became mayor.

P

Parish Chest

When next you visit All Saints' Church look at the old oak box, positioned against the wall near the café. If you have time take a quick look inside, not at the church knitting circle's work but at the underside of the lid. Three iron straps and hinges tell of the past function of the box in that it was once the most secure storage location in the church. You are possibly looking at the oldest piece of furniture in the town, dating perhaps from the mid-sixteenth century.

Following the Dissolution of Monasteries, it became clear that the State no longer had direct access to births, marriages and deaths previously recorded by the monks – a concern if you want to tax the population.

Above: Three locks meant good security.

Right: The oldest piece of Kingston furniture?

Thomas Cromwell issued an injunction in 1538, requiring all parish churches to keep such records in a secure oak coffer having a minimum of two locks, preferably three, with a key held by the priest and two churchwardens or town bailiffs, requiring all to consent to the opening of the lid.

In the short time between his injunction and his execution in July 1540, it is likely that Cromwell, when visiting Henry at Hampton Court, would have stopped and prayed at the church, a short walk from the bridge crossing, and checked that his injunction had been carried out.

Pissing Place

I once saw a footnote which referred to the 'mending of ye tymbers of the Court Hall after the men's pyssing', but, annoyingly, forgot to bookmark the site. Finding that the fish market was under the Court Hall, I wondered if I had dreamt the reference, but, no, historical records support the elusive note. Chamberlains' accounts between 1653 and 1708 set down who was paid and how much for not only sweeping the fish market but mending the 'pissing place'.

In 1653 timber and liquid is required for the 'stalls under Court Hall' – Fish market stalls or a totally different type of stall? From 1658, Thomas Marshall is the 'go to' man for clearing ditches, cleaning the 'p-p', digging a hole under the cisterns, sweeping the fish market and cleaning the cisterns. Old Smyth is tasked, in 1660, with carrying away the filth under Court Hall and two years later 'the plummer' is paid for mending the place. The following year R. Green is paid for 'mending the towne stalls', which, I believe, implies the 'town conveniences'.

We last hear of old Thomas Marshall in 1676. He lived out his life in the newly constructed Cleaves Almshouse and was 'interred' in 1678. In 1679 Joshua Addison is paid for a wheelbarrow to carry the 'soyle' out of the fish market.

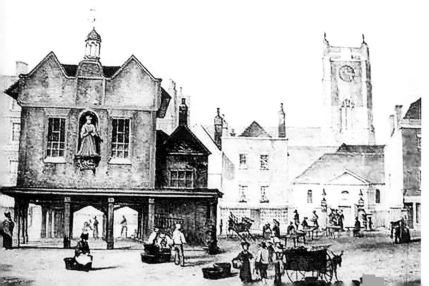

A meeting place of convenience.

With the later extension to the old Court Hall, John Brown is paid to pave the Market Place in 1704 and four years later we are left with no doubt as to where the town toilets were as he is notably paid for 'mending the pissing place under the Court Hall'.

Thomas Pooley

Thomas Pooley's story is sad, not just because he had a vision that was within his grasp only to be snatched away by conspiracy, but also because he is forgotten to history. He fully deserves the recognition that local historians Sampson, Butters and Statham have given him.

Pooley relocated to London from Cornwall and became successful and wealthy. He owned cargo vessels and ran three malthouses in Kingston.

The year 1838 saw the coming of the railway and the death of landowner Christopher Terry. Only Pooley appeared interested when Terry's land was auctioned. Seeing its potential value he snapped it up at a bargain price of £10,500 (£640,000), his aim being to build a new town for wealthy people working in London but wanting to live in the country. Pooley had seen the future spread of railways and lifestyle benefits of commuting.

Realising that his investment would reap profit, people soon offered him ten times his purchase price to sell the land. He declined the offer and, poignantly, this was the start of his financial ruin. Some saw this 'Cornishman made good' as a lower-class threat, their view tarnished, undoubtedly, by jealousy.

Pooley's new town progressed under his total control. He employed architects, engineers and builders; roads were planned, plots set out and buildings were begun and finished on a rolling programme. He saw accessibility limitations of the original station, deep in the cutting through Surbiton Hill, so gave land to the London and Southampton Railway to convince them to relocate their station to where it is today, at the convergence of a number of Pooley's roads.

In August and October 1840, *The Times* praised him for his rapid, quality development which must have been salt in the wound of those who had missed out. Businessmen in Kingston started fearing that a bright, accessible New Kingston would see their profits reduce.

To progress at speed Pooley constructed properties simultaneously and, to finance this, he committed to borrowing from Coutts Bank, paying them back in instalments once a property was completed and sold, but this was his Achilles' heel. If the workforce tarried, and houses were not completed or sold, he had insufficient capital to pay the increasing interest on the loan. So it began. Completed houses were immediately damaged by 'parties unknown' and could not be sold without further investment. Pooley couldn't sell the damaged properties and he couldn't build or complete the unfinished houses.

His solicitors, who had a ear and perhaps a pocket turned towards Kingston, advised Coutts of Pooley's predicament. Coutts understandably called time on their loan.

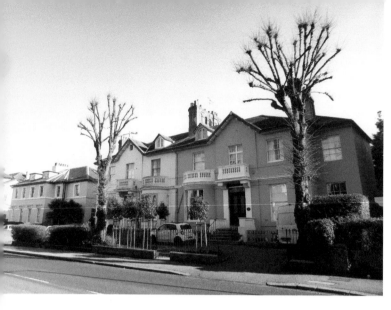

Two of Pooley's houses
in Claremont Road.

In desperation, he tried to broker a deal whereby he would hand over his claims for a life annuity. Coutts declined and he had to hand over his holdings to his creditors.

Surprise, surprise! Now under the control of Coutts, all vandalism promptly stopped, houses were repaired and sold; the workforce was paid; new houses completed and Surbiton rapidly developed and profits were most definitely made, but not by Thomas.

His original road names were changed. Alexander Road, named after his son, became Victoria Road and all traces of Thomas were erased. Pooley disappeared from history and, tragically, is understood to have taken his own life.

His legacy can, however, be clearly seen in today's Surbiton and in Kingston, the town that viewed him with envy. In the former, his grand houses still stand but it is his effect on the latter that is so oft overlooked.

Thomas' new town needed local shops and these were brightly lit and spacious. People preferred shopping there and, by so doing, retailers in Kingston had to change their ways – and dimly lit shops. Kingston shopping changed in direct response to Pooley's new shops and so, in many respects, the retail success of Kingston thereafter and to the present day can be attributed to Thomas Pooley from Cornwall.

Pottery

The summer of 1264 saw frantic activity in Kingston. Henry III had ordered 1,000 wine pitchers for the forthcoming Feast of St Edward. In the following two years a further 2,800 pitchers were sent to the king.

It was previously believed the King's pottery had been made elsewhere. However, an excavation in 1969 at Nos 70–72 Eden Street and discovery of part of a kiln and over a half a ton of pottery changed how Kingston was viewed. It became accepted that the town once had a thriving pottery industry.

In 1982 another kiln was found between Eden Street and Union Street, opposite the earlier site, dating from the mid-fourteenth century and then, when construction of

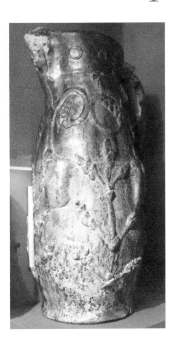

An example of Kingston-ware pottery. (Photo courtesy of Kingston Museum)

the new C&A store (now Primark) began in 1995, the second half of the 1969 kiln was exposed, along with three further kilns dating from the early fourteenth century.

These kilns could not have produced Henry's pitchers. However, excavations during the construction of the Rotunda in 2000 revealed late twelfth-century and early thirteenth-century pottery and two years later, in Old London Road at the Travelodge site, further evidence of the pottery industry was revealed, with another kiln and waste pits.

All these finds led to a re-evaluation of Kingston's part in the pottery industry and the production of what is now termed Kingston-ware. Examples of pottery and a reconstruction of a kiln are featured in the museum which, once again, I urge you to visit.

Pratt's Passage

You may never have ventured down this narrow passageway alongside Marks and Spencer in Clarence Street. It is a shortcut that comes out at the side of the Memorial Gardens and also between the Eden Walk entrances of Marks and Spencer and Boots.

It is there because James Carter, draper, who acquired the land in a sale in 1823, and later saw construction of thirteen cottages, called Young's Buildings, stipulated that permanent access be provided to London Street (Clarence Street).

But who was Pratt? Ayliffe provides a description of the south side of today's Clarence Street from the corner of Eden Street (previously Heathen Street) to the passage. He relates:

Pratt's Passage
alongside Marks
and Spencer.

At the corner of Heathen Street stood the builder's yard and workshop of Mason and Sons, enclosed with a very high wall. Then came John Triggs' stonemasons yard and workshops; a couple of villas were next in order and then another builder's yard belonging to Mr Brooks.

Adjoining these were the malt-houses and brewery of Mr Francis Broughton, part of which was later converted into a beer-house called 'The Comet', part into a currier's shop, and another portion became the premises of Thomas Jones. A shop for leather goods, boxes and trunks, kept by Mr Pratt, was next in order, and then came the archway leading to what is now called Young's Buildings.

Census returns of 1841–61 advise that the shopkeeper was William Pratt, a bonnet maker, later a clothier, living there with his wife, Ann.

The passage originally ran straight and had a separate entrance opposite the old post office but was narrowed, shortened and redirected when the Eden Street development saw the demolition of Young's Buildings.

Pump

Ayliffe describes the town pump in the Market Place outside the main entrance to the parish church as 'a quaint old structure of wood and iron, on top of which was a lamp which was lighted after darkness set in'. He recalls, 'Here was a spring of beautiful water, and most inhabitants of the Market-Place and the surrounding district fetched their water for domestic purposes, no doubt being here, as at the pump in the Horse fair, there was nothing to pay for it.' Accounts indicate that in 1702 Richard Webb was paid £1 (£110) for erecting the pump in the Horse Fair.

Q

Quads

On 5 and 6 March 1673–74 George and Ann Dennes must have wondered what was happening as Ann gave birth. First they had one child, then twins, triplets and then, a fourth child was delivered! Three boys and one girl 'all born alive, lusty children and perfect in every part'.

Sadly, within twenty-four hours all children had died. Burial records show three male children and one female, all unbaptised, buried on 10 March 1673.

Fourteen days later, on 24 March, George buried another daughter, Ann, and tragically, two days after that, he buried Ann, his wife.

Queen Anne

Two detailed and artistically renowned depictions of Queen Anne can be seen in the town. One, Francis Bird's lead statue, gleams golden and proud surveying her local realm from the Market House. The other is not so evident. It used to be inside the Market House but was relocated to the new Guildhall after construction was completed. It is a 1706 portrait by Sir Godfrey Kneller, court artist serving all English monarchs from Charles II to George I. Kneller, who lived nearby, donated the painting to Kingston, most likely for the opening of the enlarged Town Hall and erection of the Bird sculpture.

History comes alive when one finds, hidden within the Chamberlains' accounts for 1706, a record of a payment of 1s 6d to 'Board, the workman, for hanging the Queen's Picture'.

Above left: Francis Bird's statue of Queen Anne on the Market House.

Above right: Sir Godfrey Kneller's portrait of Queen Anne in the Guildhall. (Photo courtesy of Kingston Council)

Queen Elizabeth I

Queen Elizabeth was so impressed by Kingston's 'isolation principles' during the plague year of 1593 that she wrote to the Lord Mayor and Aldermen of London suggesting that they follow the principle:

> They pressentlie upon the fyrste infection caused an house to be made in the fields dystante from the towne, where the infected might be kept apart and provided for all things convenient for their sustenance and care which, yf so little a town as Kingstone is able to pereforme, we cannott but thinck that the Cittye of London should cause some fitt lodginge to be made in some conveynent place without the cittye where those that are infected might be kept apart.

People still succumbed with eighty-seven burials resulting from plague, but considering that this was only 45 per cent of the total deaths that year, it shows that there was a degree of containment.

The Museum of London tells that the first regulations to stop plague were introduced in 1518. A bale of straw was required to hang outside an infected house for forty days and people from such an infected home had to carry a white stick when they went out to warn others to stay away.

R

Rabies

Thankfully, the risk of contracting rabies in this country is small. The last death from indigenous rabies was in 1902. But there was a time, not so long ago in Kingston's history when, as Sampson writes, 'Rabid dogs were a dangerous feature of Kingston's streets.'

In April 1886, there were 373 reported cases of hydrophobia caused by dogs in the London area. To reduce the risk, stray dogs were rounded up and Sampson advises that, in Kingston, 605 were captured. Three years later a serious dog bite in a confectioner's shop in Thames Street made the news.

Police Constable Samuel Copping (twenty-four) was called to G and C Nuthall to remove a stray collie dog that was causing public concern and in the attempt he was severely bitten. Police authorities immediately sent him to Paris to be treated by Louis Pasteur at his laboratory where a treatment for rabies had been developed. It was a race against time. Pasteur's research had revealed that the virus often lay dormant until being later triggered, after which death inevitably followed. However, if the infected party was exposed to a faster-acting, weakened form, then immunity from the fatal infection could be provided.

In an address entitled 'The Life Work of a Chemist' given by Sir Henry Roscoe FRS, he references Copping, when he tells of having visited the Pasteur Institution, described as resembling an 'out-patient department of a great hospital'. He continued, 'There I saw the French peasant, the Russian moujik (suffering from the terrible bites of rabid wolves), the swarthy Arab, the English policeman, with women too and children of every age; in all perhaps a hundred patients. All were there undergoing the careful and kindly treatment, which was to insure them against a horrible death. Such a sight will not be easily forgotten.'

Fortunately, after the three-week treatment, Copping recovered and returned to Kingston. In 1891 he was stationed at London Road; in 1901 he was married to Elizabeth and was living in rooms above the stables of Pembroke Lodge in Richmond Park, where he was still a police constable. In 1911 he was a grocer in his home town of Wilby in Suffolk, having taken his police pension. He died on a train between Richmond and Kew Gardens on 13 November 1929, aged sixty-seven.

In October 2018, the *Daily Telegraph* reported that, worldwide, there are 55,000 human deaths annually due to rabies – that's 150 each day, with 99 per cent caused by infected dogs.

Roundels

When Clarence Street was pedestrianised in 1989 special features were provided to emphasise road junctions and a series of patterns designed by architect Paul Oakley were created and called 'the Roundels', each depicting parts of the Royal Borough.

There is no design at the end of Church Street and yet, totally out of position and unexplained, is a blank roundel in the paving outside the Bentall Centre. This was to be the Tolworth Roundel designed to be positioned just before Memorial Square, balancing with the Surbiton roundel in Clarence Street. Intended to be included in a later phase, it never materialised.

To try and right this oversight for Tolworthians, all I can tell you is that the image would have comprised three striped shopfront blinds, to represent Tolworth Broadway.

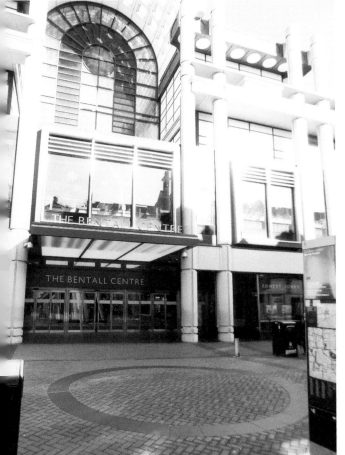

Above: The design for the final 'Tolworth' roundel.

Left: The 'empty roundel' outside the Bentall Centre.

S

Seven

Despite what you may read or see on the colourful mural in Eden Street, on the heptagonal plinth under the Coronation Stone or even at a car park, there is only evidence that two kings, Athelstan and Ethelred, not seven, were crowned here.

Step inside All Saints' Church and there is an altogether different significance for the number 7. In the dimly lit memorial chapel dedicated to the East Surrey Regiment you will see inlaid on the timber panelling the image of a Victoria Cross, awarded for gallantry in the presence of the enemy. Beneath the medal are the names of seven members of the East Surrey Regiment who were awarded the Victoria Cross in the First World War. These were:

Lieutenant George Rowland Patrick Roupell VC
Second Lieutenant Benjamin Handley Geary VC
Private Edward Dwyer VC
Second Lieutenant Arthur James Terence Fleming-Sandes VC
Corporal Edward Foster VC
Sergeant Harry Cator VC
Corporal John McNamara VC

Just names, perhaps, but each went above and beyond the call of duty. I cannot herein do them justice so ask that you 'adopt' at least one and, respectfully, check on the internet for what he did.

The chapel is full of names and commemorations but, for me, the plaque with the names of a father and son demonstrates the poignancy of war. Major Walter George Spencer (born in October 1918) was killed in Italy on 21 November 1944, aged twenty-six. His father, Captain Walter George Spencer, died of his wounds on 26 March 1918, when his wife was only two months into her pregnancy. Neither father nor son saw the other and both lives ended prematurely due to conflict.

Sopwith

Thomas Sopwith chose Kingston because of its long history of boatbuilding and skilled workmanship in timber and fabric. He hired and then purchased the roller-skating rink in Canbury Park Road for his first workshop.

We owe a lot to Sopwith Aviation and to 'Tommy' himself. But without explanation their achievements remain lost in the clouds. However, the informative Kingston Aviation Centenary Project (KACP) advises that the following were all 'Designed and Built' in Kingston:

The 1st British Flying Boat; The World's first practical amphibian (take off/landing on land or water); 1st British Aircraft to win a major international air race; 1st aircraft to destroy a Zeppelin Airship (albeit bombing it on the ground); 1st two-gun, two seat fighter (firing front and rear); World's 1st fixed-gun single seater fighter; 1st aircraft to land on a moving ship; 1st Triplane fighter (Anthony Fokker inspected a captured Sopwith and instructed his designer to build one, but they did not copy the Sopwith design, just the concept); Sopwith 'Camel', the most successful allied fighter of the First World War; World's 1st 4-gun fighter; Sopwith 'Snipe', RAF's standard fighter until 1925; 60% of single-seat aircraft built for the British services in the First World War; 18,000 'Sopwith-designed' aircraft; 1st British Torpedo plane to operate from aircraft carriers.

The roller-skating rink in Canbury Park Road later acquired by Thomas Sopwith for aircraft construction.

At the end of the First World War, Sopwith Aviation was forced into voluntary liquidation, but soon after and having ensured all creditors were paid, the 'phoenix' of H. G. Hawker Engineering Co. took flight, with Sopwith in the 'cockpit', and with Camm and Sigrist 'keeping the crates' flying. Just as Sopwith Aviation, the credits for Hawkers are equally impressive:

> The Hawker Hart bomber, faster than RAF's best fighters; 'Fury' is the 1st 200 mph aircraft in RAF service; During the 1930s over 80% of RAF aircraft are Sydney Camm designs; Hurricane is the first 300 mph aircraft in RAF service; Most successful fighter in the Battle of Britain, which if lost would have seen invasion by Germany; Most widely used and successful allied fighter in WWII; 'Typhoon' is the first 400 mph aircraft in RAF service; 'Tempest' downs more V1 'flying bombs' than any other plane; 'Hunter' achieves 727 mph in 1953, the World's fastest aircraft; 1961/4 unique vertical take-off and landing aircraft ; 'Harrier' is the World's 1st operational VTOL, 'Harrier' purchased by US Marine corps, the 1st 'Foreign' military aircraft bought by the USA since 1918.

In all, approximately 45,000 Kingston-designed aircraft have been built and, as the KACP proudly declares, 'As a legacy, aeronautical engineers are still being trained at Kingston College and Kingston University.'

Sopwith Camel

I am a lifelong admirer of Charles M. Schulz (creator of the *Peanuts* comic strip). His son, Monte, used to assemble plastic model aeroplanes (similar to Airfix) and in the summer of '65, having made a Fokker Triplane and 'hand flown' it into Schulz's studio, they started talking about 'the Red Baron'. Schulz sketched Snoopy on his doghouse and drew a flying cap and 'The World War One Flying Ace' took off to fight the Red Baron. Schulz thumbed through his son's book on fighters and found the name that suited – The Sopwith Camel, made in Kingston and destined to forever fight the Red Baron in his Sopwith triplane-inspired red Fokker triplane.

The Camel design had a flaw which the hands of experienced pilots turned to their advantage. The gyroscopic action of the engine made turning left very difficult. Pilots would turn right and under to go left. Turning left in untrained hands led to stalling and a potentially fatal spin. The Camel saw the loss of many novices taking their first solo. Experienced pilots said, 'With the Camel you WILL get a cross – either a wooden cross, a Red Cross or a Victoria Cross!'

As for the name, a metal fairing over the gun breeches, protecting the guns from freezing at altitude, created a 'hump' that led to pilots calling the aircraft a 'Camel'.

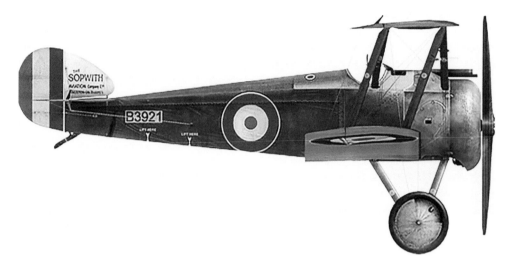

The Sopwith Camel. A total of 5,490 were built in Kingston and Camel pilots were credited with destroying 1,294 enemy aircraft.

Stained-glass Windows

Most people, hearing the term 'stained glass', think of a place of worship and the 'poor man's bible', whereby religious texts were illustrated in windows before the congregation could read. There are, however, other buildings where this specialist art and craft is evident. The 1930s Wood Street entrance to the Bentall Centre has four roundels depicting crests of local counties and there are a few random pieces in Church Street.

The decorated façade of the Market Place building (currently Jack Wills) has a stunning 'Coronation' window lighting the stairs to what once was the first-floor reading room of Boots' Library. Jesse Boot wanted his library to resemble that of a stately country house and high-level stained-glass coats of arms in the windows were used to promote this ambience. One of these coloured arms is that of Dr W. E. St Lawrence Finny, seven times mayor, antiquary, who designed stained-glass windows for the old Town Hall, now the Market House. In 1934 each of his windows was carefully dismantled and transferred to the museum, where they are displayed today – yet another reason to visit your museum.

The museum's window known as 'Several Kings' incorporates coloured glass made in 1618 and 1663 which originally featured in windows of the earlier Tudor and later Stuart-enlarged Town Hall.

Look for Finny's 1911 copy of an old window found in Betley Hall, Staffordshire, depicting characters of the late spring plays and dances which are recorded in the Kingston churchwarden's accounts as the 'May Game'. His window provides a glimpse of the fun and games of Kingston's Tudor past.

Above: Kingston's stained-glass specialist at Fairfield Corner, Hawks Road.

Right: Museum window mainly composed of stained glass from 1617 and 1663. (Photo courtesy of Kingston Museum)

Kingston currently has its own resident stained-glass artist, Simone Kay, whose studio and workshop is Hawks Road and who has been making works of art for over thirty years.

John Stilles

Parish registers provide a fascinating window to the past and burial records occasionally highlight premature or unnatural deaths.

Drownings are common, Kingston being an inland port on the Thames, although the death of John Akerleye, buried 4 June 1593, is poignant in that he 'went to bathe himself and was drowned'. People often bathed prior to marriage. There are murders, an accidental 'incineration', three people killed by carts and, in 1600, Agnes Hewett was 'killed with a horse'.

However, the demise of John Stilles deserves particular mention. He was buried on 3 April 1605, three days after Easter Sunday but, more importantly, two days after 'All Fools' Day', when Lord of Misrule took charge for the day and caused mayhem with jokes and jests. It seems that things got somewhat out of control as John Stilles' burial record states he was 'killed with a bear'. The name and fate of the bear is not recorded.

Tenterfield

If you are 'on tenterhooks' you are stretched to your limits. A tenter was a wooden frame used in the woollen trade. Woven cloth was washed to remove natural oils and dirt and, to prevent shrinking, it would be held taut on the frame with self-made edges (selvedges) held by tenterhooks. Tenters often formed boundaries of fields.

Kingston's 'Tenterfield' is believed to have been south of the Hogsmill and east of the High Street and Portsmouth Road where The Rose and Bittoms car parks, Nandos and Pizza Express are currently located, extending to the college and crown courts. The old road to Surbiton, now Wheatfield Way, formed the eastern boundary.

Kingston College, in the background, is built on the site of the 'Tenterfield'.

Finny tells of a 1339 grant of an acre of land 'in Teyntronfeld at le Buttes'. Etymology can be confusing. 'Butts', from French, means a target as in archery, whereas in Old English it means an end or strip of land.

In 1565 a lease of an acre of the Tenterfield imposed a condition 'to leave suffycyent way for ye archers to go yn and owt to a roundle standyng and being in and upon seid acre of land above letten, at ye east ende thereof, nereynte the highway there, leading from Superton to Hoggs Myll, to pastyme and shoote at ye saide rounde at all tymes'. Clearly, this was where the townsmen practised archery.

When you next pass College Roundabout and see *Paper Trail*, the 2012 sculpture by Michael Antrobus and Tom Kean, remember the bowmen who once stood in the field loosing arrows, not darts, in your direction.

Tithe Barn

Until its demolition, the great square Tithe Barn, measuring 90 feet length and breadth, stood where the station is today and was where the vicar's share of all the grain grown in the parish was threshed and stored.

It had four separate openings, centred on each face and was considered one of the largest in the kingdom. It had a high tiled roof supported by heavy timbers and Biden advises that it had 'sufficient accommodation for the unloading of a score of waggons at one time'. He recalls 'a gentlemen still living' (Biden, himself?), in his younger

The model of Kingston (1813) in the museum. The Tithe Barn is the square in the top left corner. (Photo courtesy of Kingston Museum)

days, 'being driven in a phaeton with four horses in hand, not only through each of the four entrances but also at full trot around the inside of the barn, such was its immense size'.

Ayliffe recalls how, in 1841, the Metropolitan Police sent a contingent of constables from London, who lodged in the barn ready to assist the local authorities in quashing the Shrove Tuesday football match. The attempt to prevent the game was abandoned and having nothing else to do, a quantity of Rowell's ale was acquired and, accompanied by a fiddler, 'Blind Harry Johnson', the barn became the venue for an impromptu 'policeman's ball'. Come time to return to London, many had imbibed far too much and could not get into the vans that had brought them.

In 1843 the barn was sold by public auction for £160 (£10,000) and promptly pulled down and removed and with it went the cucking stool that was stored there.

The site of the great Tithe Barn at Canbury Farm.

U

Undercroft

In 1986, Kingston became the site of archaeological innovation, with the preservation of the fourteenth-century chalk- and black flint-lined undercroft located beneath the site of the old Rose and Crown Inn at the corner of Thames Street and Old Bridge Street.

Though simply 'a cellar', probably housing bottles and barrels, its age and chequered lining shouts 'medieval quality' and it provides a link with the time when the town acted as a port. Wine shipped from Bordeaux found its way to Kingston.

During the 1986 John Lewis development, the medieval street layout leading from the Old Bridge, via Thames Street to the Market Place and the adjacent Horsefair, had to be excavated.

The seventeenth-century Rose and Crown Inn was demolished in 1900. The cellar had been discovered during demolition, had been catalogued, buried, built over and totally forgotten until excavations commenced.

Specialists in basement construction, Pynfolds Ltd was commissioned to secure the cellar in its entirety, such that it could be lifted, removed, stored and then returned to a more accessible location. They encased the cellar within a concrete shell, with lifting supports, then hoisted it up onto a trailer and away went the undercroft. It returned in 1988 and is today displayed alongside the stone foundations of the original Kingston Bridge.

The Rose and Crown was previously known as the 'Oystredge Fether', a name dating back to Edward III, feathers being the heraldic badge of the Prince of Wales as seen today on the reverse of a 2p coin. The plume came from the Arabian ostrich, later hunted to extinction, not from African ostriches known today.

The Undercroft in the basement of John Lewis beside the river.

V Division

Metropolitan Police were stationed in London Road from 1840 until the 1969 opening of the new police station, alongside the Hogsmill. They were designated as V Division (Wandsworth), one of seventeen policed areas each assigned a letter that divided the 154 square miles within a 7-mile radius of Charing Cross.

In addition to their 'beats', the Commissioner stated in a Police Notice that there were 'fixed' points to which a Police Constable was to be found between 9 a.m. and 1 a.m., these being outside Kingston and Surbiton railway stations, the Market Place and Kingston Hill. It is for this reason that PC Fred Atkins, twenty-three, was stationed at Kingston Hill late into the evening of 22 September 1881. Investigating a noise, he disturbed a burglary and was shot, dying the next day. His murderer and accomplice escaped and his murder remains unsolved.

Atkins' murder is a case of one being in the wrong place at the wrong time. PC Andrew Cavanagh, thirty, should have been on duty that night. However, the day before he had been on duty at a race meeting in Hampton and wasn't assigned his beat that night. Poor Fred Atkins, remembered today in the memorial gardens of Kingston police station and the old New Malden station (now The Watchman), should never have been at Kingston Hill.

The memorial to PC Atkins of V Division outside Kingston Police Station.

V2

For people at the junction of Park Road and New Road, at 2.35 p.m. on 22 January 1945, there was, for a moment, complete and utter silence. Not a 'peaceful silence', it was more like a scene from a horrific silent movie. Walls falling, roof tiles sliding, shattered windows and glass smashing noiselessly; people lying injured, others running, mouths open, yelling, screaming in silence; papers fluttering to the ground; earth, masonry, timber splinters raining down on the ground and a smoke cloud billowing, with not a sound to be heard.

A V2, one of Hitler's potentially war-winning and devastating *Vergeltungswaffen* (Vengeance Weapons), had just slammed into a garden behind No. 1 New Road, at almost three times the speed of sound. The silent killer created such a deafening blast that survivors suffered a temporary loss of hearing.

Seconds before all was fine but then, without any warning, thirty-three houses were destroyed, 2,000 or so homes were damaged, eight people lost their lives, and another 117 were injured. A crater, approximately 60 feet wide and 30 feet deep, appeared 'from nowhere'.

The event is commemorated by a stone plinth set back from the road at the corner of the junction of Park Road and King's Road. Two inscribed plates, set into the stone, provide an account and the names of five who died, three others being unnamed.

Fortunately, and despite many V1 attacks, this proved to be the only V2 to land in the Royal Borough.

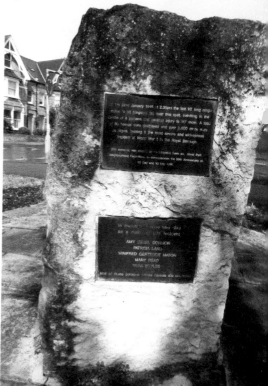

Above: The junction of Park Road and King's Road where the V2 rocket landed.

Right: The memorial stone, commemorating the names of those who died.

Wife-selling

'A few days ago that barbarous custom of selling a wife in a halter, was exhibited in the public market place of Kingston-upon-Thames.' So begins an article in the 1 May 1817 edition of *New Monthly Magazine*. It continues, 'The woman was conducted with a halter around her neck to the town-hall by her husband, who after paying two pence for the right of selling, put her up to auction, when she was knocked down at the sum of one shilling, to a lusty inhabitant of Woking in Surrey, who led his very valuable and haltered bargain off in triumph, amidst the disgust and reproaches of all those witnessing such profligate and indecent conduct.'

Barbarous or a means to an end? Despite condemnation of the public as reported, prior to the first divorce court 1857, an annulment of a marriage required both an Act of Parliament and acceptance of the Church. Women therefore often insisted on an auction transaction as a simple, though not legal, means of ending an unhappy marriage and could decline an offer if they disliked the potential buyer.

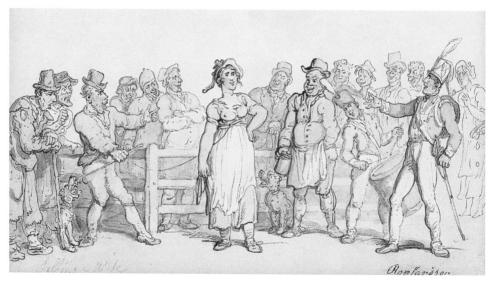

Selling a Wife by Thomas Rowlandson (1812–14). The wife appears very amenable to the sale.

Wright

Churchwardens' accounts are amusing. In 1509 a stile is provided in the fencing around the church. The following year, 2*d* (£6) is paid for carrying a dead horse out of the churchyard. In 1536, 4*d* (£7) is paid for a locke for the stile – but the horse has already ... never mind!

But consider the thought processes for employing Mr Wright who, in 1577, is paid 6*d* (£6) for 'throwing away the donge from the Churche yarde'. A year later they realised where the 'donge' was coming from as he was paid 12*d* (£12) 'for beating the dogges out of the churche'.

X Shillings to 'Stay Away'

Kingston was regularly visited by touring bands of actors, including the Prince's Players, whose patron was the future Charles I, and the King's Players, whose patron was James I and who, during Elizabeth's reign, were the Lord Chamberlain's men, the troupe to which Shakespeare had belonged before his death in 1616 and who held exclusive rights to perform Shakespeare's plays.

In 1621, Chamberlains' accounts, for Kingston, record 'Paid by Mr Bailiff to a company of players because they should not play in the town hall - x. s'. Then in 1625, 'To the King's Players because they should not play in the town hall nor in the towne for the space of five years - x. s'. This may have been due to fear of their bringing plague to the town. Fifty-six people in Kingston succumbed to plague that year. Richard Cooley, one of the Lord Chamberlain's men, was interred on 7 December.

Not surprisingly, having received 10 shillings to stay away, the troupe returned the next year and accounts note 'To the King's Players to forbeare to play in the towne - x. s'. In 1633, they were once again paid x shillings, though it is not clear whether they were allowed to play or not.

Yew Tree

Churchyards often have an evergreen, traditionally a yew tree, its evergreen foliage associated with everlasting life, predating Christianity. In 1570, 1s 4d (£16 today) which, at the time, would pay for four days' labour, was 'payd to Gylbard Margarre for dyggyng dovne the yewe tree'. Sadly, we don't know why.

All Saints' Church currently has two, comparatively young, yews on the northern side with holly to the east and south. Pre-Christian beliefs, adopted by the Christian church, are alive and well in the churchyard.

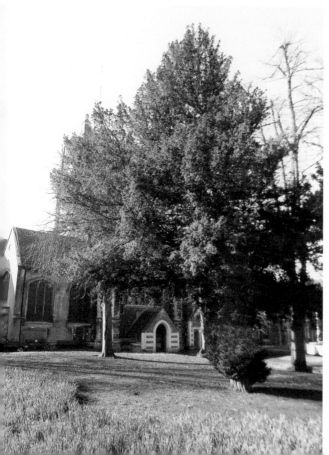

An evergreen yew tree in the north churchyard.

Yewsabit

Remember that pile of coconut shells at Middle Mill? Hugh Harries, research associate at Kew Gardens, believes the downstream mill (once called Hogg's Mill) used Middle Mill's refuse as its secret ingredient in the metal polish 'Yewsabit', which, as a lover of wordplay, I applaud. Branding depicted a drummer of the Guards, a red tin as his base drum, alongside which they punned 'We beat all'.

Yewsabit was sold to the army and was in great demand in the Second Boer War – not the most shining example of Britain's military exploits.

Hughes' suggestion that coconut shell waste was used is plausible as, in 1901, manufacturer Johnstons and Co. admitted that the 'secret' ingredient in their polish was 'put through a powerful mill and ground to a fine powder'. Almost certainly linked with the earlier demise of the local coconut industry and the exhaustion of the ingredient, the Yewsabit mill had closed by 1910. For a time though, by using the upstream mill's coconut waste, it was a case of 'Where there's muck, there's (clean) brass!'

The name 'Yewsabit' reappeared years later in Australia, associated with a facial cleanser. Perhaps someone thought that if it could clean the army's brass it could work wonders for the skin.

Above: The 'Yewsabit' name transported to Australia and applied to faces.

Right: 'We beat all' Yewsabit tin, with free puns. (Photo courtesy of Richard Quinton)

Young's Buildings

A row of thirteen early nineteenth-century cottages secreted in the middle of Kingston between Eden Street, Clarence Street and Union Street sounds quaint and today would probably be highly sought after and each occupied by a single individual, a couple or a family.

In 1861, the occupancy of each cottage ranged between six and seventeen, with eight of the thirteen having ten or more occupants. It was not unusual to find a family of five or six living in one room and four separate families to each cottage. There was no piped water and, as Butters describes, 'nearly all the privies are full to the floor and are frequently running over'. The 1911 census reveals a similar picture but with some improvement as only three of the thirteen cottages have more than ten occupants.

The buildings were accessed through an arch on the west side of Eden Street, opposite Ashdown Road and, separately, through Pratt's Passage onto Clarence Street. Ayliffe recalled that Young's Buildings were once known locally as Cato Street as the original builder was reputedly connected to the famous Cato Street conspiracy. Frustratingly, no evidence supports this intriguing statement.

Young's Buildings with Pratt's Passage snaking in front between the cars and the dwellings. (Photo taken by E. W. Bryan and supplied courtesy of Kingston Heritage Service)

Z

Zoological Society Research Centre

Travellers over Kingston Hill in the mid-nineteenth century could be forgiven for believing, for a moment, that they had been visually transported to Australasia, India, Africa, Canada and even South America. Alongside the road they would have seen kangaroos, emus, Sambar deer, zebras, elk and even llamas.

London's Zoological Society's gardens opened in 1828 for scientific study, the public being granted access in 1847. After accession, June 1830, William IV donated the Royal Menageries of Windsor Great Park and the Tower of London to the Society, thus transferring the cost and responsibility for the upkeep and separating himself from extravagant expenditure at a time of European revolutions and political reform. This is a fine example of 'gifting a white elephant'.

The Society secured the lease of a farm on Kingston Hill and it became a breeding station, a centre for scientific research and an 'animal hospital'. Ayliffe recalls having

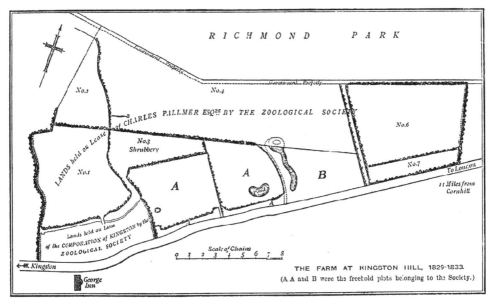

Map indicating the site of the Zoological Farm on Kingston Hill.

seen four lion cubs born there but was saddened to hear that they were soon after devoured by the lioness.

For three years the farm bred birds, fish (stocked in the natural ponds) and mammals but, whether due to financial burden of the 'white elephant' or mismanagement, the farm had to be given back and research transferred back to Regent's Park. Stock was dispersed to other zoos or culled.

Speculation as to the origin of the ringed-neck parakeet population in Surrey has placed fanciful 'blame' on the filming of *The African Queen* at Shepperton Studios or Jimi Hendrix releasing a pair in swinging Carnaby Street. However, a pair was first recorded as having bred in the wild in 1855. Could perhaps a chance escape of birds, when the farm closed, be considered as a 'flight of fancy'?

Zoopraxiscope

A unique Victorian invention, enabling live animal movement to be viewed and investigated, sits in a display cabinet of Kingston Museum. Sadly, to many readers, this will be of no immediate interest.

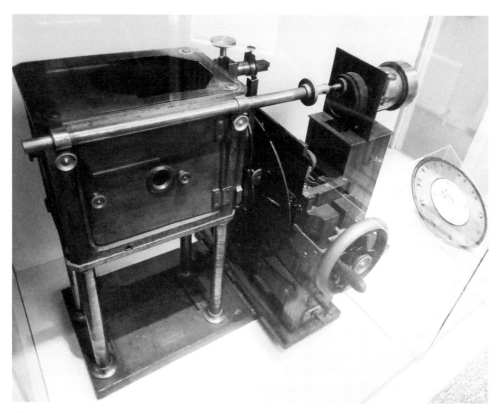

The Zoopraxiscope. (Photo courtesy of Kingston Museum)

In that very same cabinet, there is an apparatus that the scientific world considers the link between still and motion photography; equipment that directly inspired Thomas Edison to invent the Kinetoscope and led to the birth of cinema. It is the only one in the world and it is in our museum! Interested? Kingston Museum doesn't just have 'a Zoopraxiscope' but 'THE Zoopraxiscope', the only one, unique, as invented and later bequeathed to the museum by Eadweard Muybridge of No. 30 High Street, Kingston.

Muybridge combined known visual techniques of simple 'Parlour Room toys', these being the Zoetrope, which created the animated impression of movement and the Magic Lantern, which enabled still images to be projected onto the wall of a dimly lit room. His invention comprised a fixed lantern, in front of which a glass disc was placed and rotated, the fixed point of light passing through the images and projected onto a display screen.

The difference between the Zoopraxiscope and previous 'toys' and its significance to history is that the images projected were derived from a still camera. Admittedly, they had to be copied by hand onto glass discs but they depicted live movement, in real time, and could be studied.

Muybridge publicly demonstrated his invention across America. He met and had further discussions with Thomas Edison after the latter had attended a demonstration. Muybridge proposed projection being accompanied by sound from Edison's phonograph, but the two inventors never worked together.

Muybridge started out as a bookseller and was probably well read. He may well have seen the work of long-forgotten Austrian General Franz von Uchatius who, by 1853, had invented a projection machine comprising twelve lenses angled to focus at one point on a screen or wall. Behind each lens he placed a glass disc, each with a separate image of a shell in flight. His aim was to visually assist his lectures on ballistic theory. A limelight was rotated behind the fixed discs such that it shone through each hand-painted shell. The faster he cranked the light around the twelve fixed images, the faster the shell appeared to fly through the air.

Muybridge chose one lens and one fixed light and simply rotated his glass disc. Muybridge's reputation as a still photographer across America placed his invention, not von Uchatius', in front of Edison. As Muybridge is rightly considered the 'grandfather of the movie industry', then, I believe, von Uchatius should be remembered as a great-uncle.

Having reached the end of the alphabet, I once again urge you to visit Kingston Museum to see this historical invention and other wonders of Kingston's past, not least the work of Thomas Abbott.

Acknowledgements

No historical work, of any form, can progress without reference to those who have set the path and we are all indebted to them for their works. Since research today often requires use of the World Wide Web, I feel that Tim Berners-Lee always deserves prioritised acknowledgement.

Thanks must always go to my lovely wife Carys, for her assistance, love, support and apparently inexhaustible patience and endless supply of bacon sandwiches during the preparation of this book. Thanks as always to Lyall and Luke for being two sons who make a dad feel so proud to say they are *his* and also for Lyall's invaluable help with improving the quality of the images.

I am indebted to the Kingston History Centre and Kingston Museum for their archives and displays and for helping me eke out historically valuable little nuggets, here and there.

Whilst the majority of photos are by the author, there are image reproductions in this book. Endeavours to locate every copyright owner have not been successful and the use of such images is on the basis and belief that the images are in the public domain and/or that copyright has expired. I sincerely apologise if anyone feels that I have used an image without credit. Please contact me and I will make amends in future reprints.

Thanks to fellow Amberley author Tim Everson for mentioning Humiliation Ann.

About the Author

A qualified Kingston upon Thames tour guide and a founder member of the Maldens and Coombe Heritage Society, Julian's passion is searching for obscure or forgotten historical nuggets relating to Kingston and New Malden that he believes lie waiting to be found, brought to light and enjoyed by all. He is a treasure hunter where the treasure is the 'quirky', buried in old books, and is a would-be detective and 'solver of the unsolved'. He was 'off school' the day they studied 'Brevity' and 'Curbed Enthusiasm'.

Julian is a Chartered Design Engineer and a Building Services Consultant by profession and has lived in New Malden for forty-two years. This is his third Amberley publication and follows *Secret Kingston upon Thames* and *Kingston upon Thames in 50 Buildings*.